IMAGES
of America
NETHER PROVIDENCE

ON THE COVER: The Delaware County and Philadelphia Electric Railway Company completed a trolley line along Baltimore Pike from the Angora section of Philadelphia to Media, Pennsylvania, in 1894. This line became part of the Southern Pennsylvania Traction Company on July 1, 1910. Shown here in 1910 running along Baltimore Pike in Nether Providence Township, the Media-Angora line ceased operations on August 2, 1930. (Media Historic Archives Commission.)

IMAGES
of America

NETHER PROVIDENCE

Michele S. Davidson

ARCADIA
PUBLISHING

Copyright © 2010 by Michele S. Davidson
ISBN 978-0-7385-7263-5

Published by Arcadia Publishing
Charleston, South Carolina

Printed in the United States of America

Library of Congress Control Number: 2009936320

For all general information contact Arcadia Publishing at:
Telephone 843-853-2070
Fax 843-853-0044
E-mail sales@arcadiapublishing.com
For customer service and orders:
Toll-Free 1-888-313-2665

Visit us on the Internet at www.arcadiapublishing.com

To Merv Harris, without whom this book would not have been written and whose friendship and guidance have meant the world to me

Contents

Acknowledgments		6
Introduction		7
1.	The Early Settlers	9
2.	The Growth of Manufacturing	29
3.	Educating the Children	43
4.	The Development of Community Services	53
5.	Transportation	67
6.	Recreation and Religion	81
7.	A Summer Retreat for the Wealthy	93
8.	The Arts and Crafts Community	107
9.	The Developers Arrive	117

ACKNOWLEDGMENTS

Many people and organizations generously assisted in the creation of this book. They include J. Mervyn Harris, E. Morris Potter, Timothy Plummer, Angela Hewett, Thomas Hibberd, Marc and Jamie Lapadula, Judy Hash, Al Palmer, Freema Nichols, Rabbi Louis Kaplan, Shirley Dodson, Stanley F. Bowman Jr., Edward T. Francis, Karl and Mary Schaefer, Charles Morris, Jill Hall, George Albany, Mimi Haggerty, Nancy Webster, Katie Nazaridis, Wallingford Community Arts Center, Pendle Hill, Springhaven Country Club, Wilson Oil Company, Congregation Ohev Shalom, Taylor Arboretum, Nether Providence Historical Society, Delaware County Planning Commission, Media Historic Archives Commission, Nether Providence Township, the Borough of Rose Valley, and South Media Fire Company.

INTRODUCTION

When William Penn arrived in Delaware County, Pennsylvania, in 1681, there were several small settlements in this area of the county, which were collectively known as "Providence." Providence comprised today's Nether Providence Township, the Borough of Rose Valley, Media Borough, and Upper Providence Township. In 1687, Providence was divided into Nether Providence Township and Upper Providence Township. Media Borough was established in 1850; the Borough of Rose Valley was established in 1923.

The earliest settlers, who were mostly farmers, arrived in Nether Providence Township as early as 1682. Because of the mixture of water, steep slopes, and arable soil, farming flourished in Nether Providence Township. As a result, more settlers came to Nether Providence Township in the 1700s and began to build houses and shops, many of which were located around Hinkson's Corners at the intersection of Providence Road and Brookhaven Road. During the Revolutionary War, George Washington passed through the township. Tradition also says that in 1766, Gen. Anthony Wayne was married in the living room of a house located on North Providence Road. After the Battle of Brandywine in 1777, it is believed that the same property was used as an American dressing station. Myriad Revolutionary War soldiers were buried in a cemetery adjacent to the Union Methodist Episcopal Church, which was located in Nether Providence Township until Rose Valley became its own municipality in 1923.

During the late 18th century, Nether Providence Township became a manufacturing center, with more than eight major mill complexes located in the township. One of the township's first mills was built by Thomas Leiper, who came to Nether Providence from Scotland in 1763. In 1776, Leiper bought a tobacco mill along Crum Creek at the Swarthmore-Nether Providence border. Over the next 20 years, Leiper acquired a total of 728 acres following Crum Creek to the Delaware River and built several more mills, including a textile mill and an oyster-crushing mill. Another important mill in early Nether Providence Township was Sackville Mills, which manufactured wool from 1842 until 1992. The Edge Tool Factory, which was located at the foot of Beatty Road in Beatty Hollow, produced farm and carpentry implements starting around 1848. Around 1860, the Beatty family purchased the mill, and in 1892, they sold it to the Springfield Water Company. Mill villages, such as the Village of Avondale, were often built to care for and serve the mill workers. Most of these villages consisted of tenement houses, schools, churches, and stores.

With the rise of manufacturing came the need to educate the children of the mill workers. One of the earliest schools in Nether Providence Township was the Union School, which was built near Hinkson's Corners in 1810. Other schools soon followed, including the Society of Friends School in 1812, the Pleasant Hill School in 1840, and the Briggs School in 1857, which was specifically built to educate the children of the workers who worked at Issac Briggs's brick factory. As Nether Providence Township's population grew in the 20th century, more schools were built, including the Wallingford School in 1902 and Nether Providence Junior/Senior High School in 1924.

Advances in transportation played a large part in the growth of Nether Providence Township. The railroad, which first came to Nether Providence Township in 1854, made travel to and from the city easier. Since businessmen no longer had to live adjacent to their workplaces, many Philadelphia executives started building houses in the suburbs. Servants, gardeners, chauffeurs, and nannies were then needed to service the estates. When trolley lines began to run through the township in the early 20th century, workers who lived in Philadelphia or along the Delaware River could also begin to move to less congested areas such as Nether Providence Township.

At the start of the 20th century, Nether Providence Township became home to many wealthy Philadelphians who were looking to escape the heat and congestion of the city. In fact, at one time, Nether Providence Township rivaled Philadelphia's "Main Line" both in terms of prestige and spaciousness. One of the better-known estates, called "Lindenshade," was built by a renowned Shakespearean scholar named Horace Howard Furness, the brother of the noted Philadelphia architect Frank Furness. He was also instrumental in creating the township's first library on Providence Road, which was named after his wife, Helen Kate Furness. Other prominent residents who built summer estates in Nether Providence Township included Alexander Kelly McClure (a friend and confidant of Pres. Abraham Lincoln), Alfred S. Gillette (the owner of the *Philadelphia Times*), Felix de Cranos (the French general counsel), James W. Mercur (the son of a former chief justice of the Pennsylvania Supreme Court), Howard H. Houston (the mayor of the City of Chester), and Edward Gratz (a prominent Philadelphia businessman). In addition to private estates, summer resorts were built in and around Nether Providence Township. One of the most well-known resorts was called Idlewild, and although it was technically located in neighboring Upper Providence Township, most visitors to the resort would arrive at the Moylan Train Station, which was located in Nether Providence Township. Another popular summer resort in the area was the Strath Haven Inn, which was located in Swarthmore, right outside of Nether Providence.

With the advent of the family car, the migration from Philadelphia to the suburbs, and the creation of better local roads, the population of Nether Providence Township continued to increase in the 1930s and 1940s. Developers started buying up large tracts of farmland on which they developed affordable housing for the township's residents. Some of the developments planned or built around this time include Pine Ridge, the Sproul Estates, Avondale Knolls, and Providence Village. As the population grew, the need for community services also expanded. The township's first fire station was opened in South Media in 1922, and the first police officer was hired in 1935. A local community arts center was also established in 1948 by a group of local artists.

Nether Providence Township still remains a popular area to live in Delaware County, Pennsylvania. Only 15 miles outside of Philadelphia, Nether Providence is easily accessible to people who work in the city. The township also has easy access to many highways, trains, trolleys, and buses. In 2007, Wallingford, the largest community in Nether Providence Township, was named by *Money Magazine* as the ninth best place to live in the United States.

One
THE EARLY SETTLERS

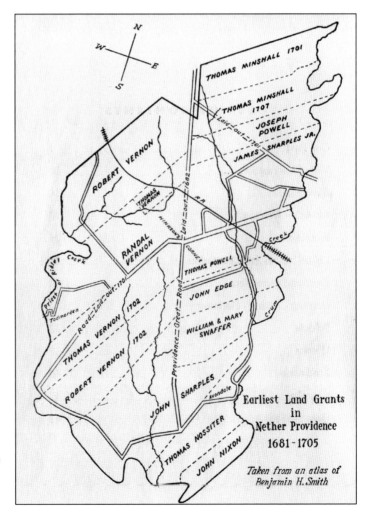

In 1681, William Penn began selling land grants in Nether Providence Township. These grants generally consisted of tracts of farmland of 100 acres or more. Because of the mixture of water, steep slopes, and arable soil, farming flourished in Nether Providence Township. As shown on this early map from the atlas of Benjamin H. Smith, some of the township's original farm families were the Vernons, the Powells, the Minshalls, and the Sharplesses. (Nether Providence Historical Society.)

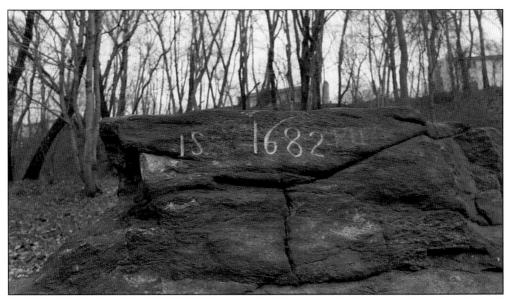

In 1682, John Sharpless settled in Nether Providence Township on a 1,000-acre tract of land along Ridley Creek. Sharpless found a large rock adjacent to the creek and built a log cabin around it. He used the rock as the back wall of the fireplace in his home. The cabin is gone, but the rock with the carved initials "J. S." and the date "1682" still exists in its original location. It is referred to as "Sharpless Rock." (Nether Providence Historical Society.)

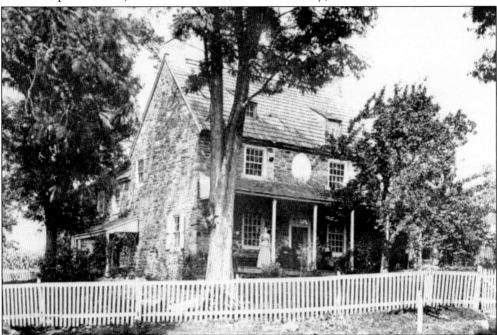

In 1683, John Sharpless began building a large house on a hilltop above the family's cabin called "Wolley Stille," which had been named for a Swedish neighbor, Olof Stille. Sharpless died in 1685 prior to completing construction of the house. In 1700, his son Joseph added a large addition to the original section of the house known as the "Great Hall." Wolley Stille is the oldest occupied house in Nether Providence. (Nether Providence Historical Society.)

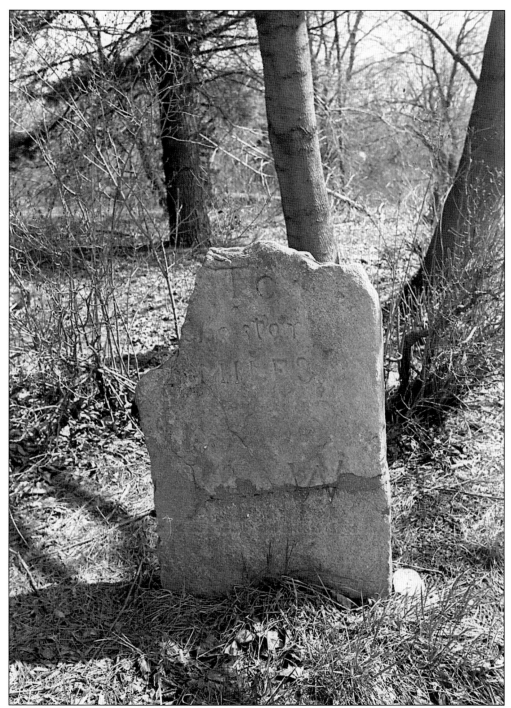

According to local historian Dr. Anna Broomall, this granite milestone located on Providence Road above Bullens Lane was erected in 1790 by Isaac Weaver, a local schoolteacher who taught at the Pleasant Hill School, which was located across the street from the milestone. The inscription on the stone reads "To / Chester / 2 miles / 1 M / IW." The stone originally had more text, but it was destroyed by an accident. (Delaware County Planning Department.)

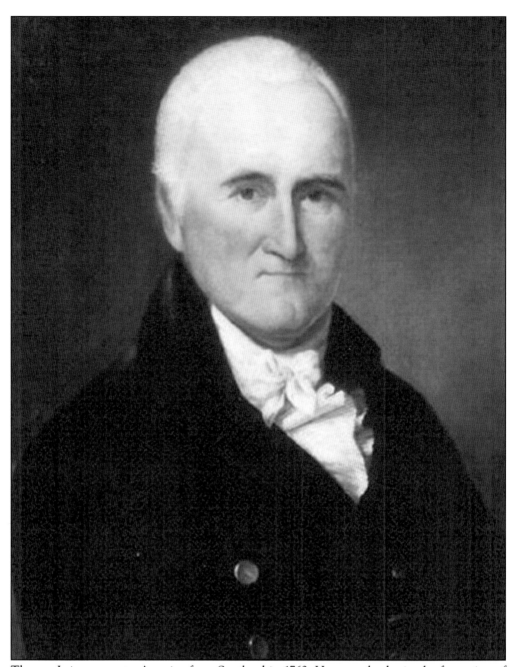

Thomas Leiper came to America from Scotland in 1763. He was a leader in the formation of what later became the Democratic Party in Pennsylvania. He was also one of the founders of the Franklin Institute in Philadelphia. In 1776, Leiper bought a mill along Crum Creek at the Swarthmore–Nether Providence border. He used the mill as a snuff (tobacco) mill and called the area "Strathaven" after his hometown in Scotland. Over the next 20 years, Leiper acquired a total of 728 acres following Crum Creek to the Delaware River and built several additional mills, including a textile mill and an oyster-crushing mill. (Library of Congress.)

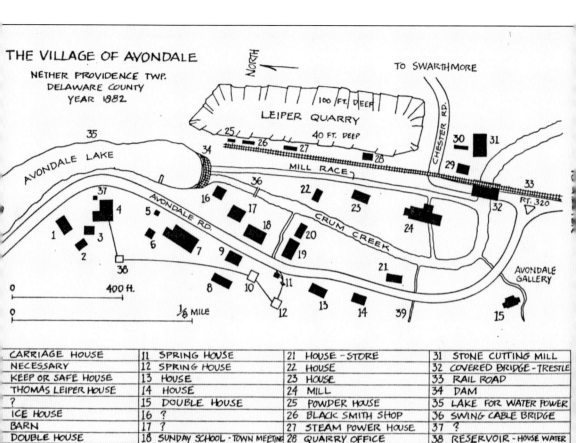

1	CARRIAGE HOUSE	11	SPRING HOUSE	21	HOUSE – STORE	31	STONE CUTTING MILL
2	NECESSARY	12	SPRING HOUSE	22	HOUSE	32	COVERED BRIDGE – TRESTLE
3	KEEP OR SAFE HOUSE	13	HOUSE	23	HOUSE	33	RAIL ROAD
4	THOMAS LEIPER HOUSE	14	HOUSE	24	MILL	34	DAM
5	?	15	DOUBLE HOUSE	25	POWDER HOUSE	35	LAKE FOR WATER POWER
6	ICE HOUSE	16	?	26	BLACK SMITH SHOP	36	SWING CABLE BRIDGE
7	BARN	17	?	27	STEAM POWER HOUSE	37	?
8	DOUBLE HOUSE	18	SUNDAY SCHOOL – TOWN MEETING	28	QUARRY OFFICE	38	RESERVOIR – HOUSE WATER
9	HOUSE	19	6 FAMILY HOUSE	29	BARN	39	CLEFT ROCK SPRING
10	RAM PUMP	20	DOUBLE HOUSE	30	TOOL HOUSE	40	

In order to accommodate the needs of his mill workers, Thomas Leiper built Avondale, a village that he named after his ancestral home in Scotland. The village included a Sunday school, a blacksmith shop, a general store, and housing for the mill workers. At the outbreak of the Civil War, this small village contributed 2 officers and 35 enlisted men to the Union Army. Most of the buildings in the village were torn down in the 1970s to accommodate the construction of the Blue Route. (Nether Providence Historical Society.)

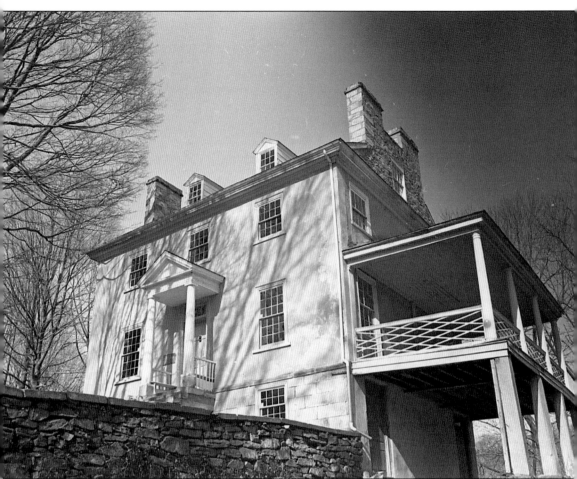

This impressive federal-style mansion, which is located at 521 Avondale Road, was built as a summerhouse in 1785 by Thomas Leiper. The west porch with its fret-work railing was added in 1786. The original French windows of the dining room (now a kitchen) have been replaced, and the paneling of the entrance hall was changed in the 1880s. The Leiper House is on the National Register of Historic Places and is currently maintained by the Friends of the Leiper House and Nether Providence Township. (Delaware County Planning Commission.)

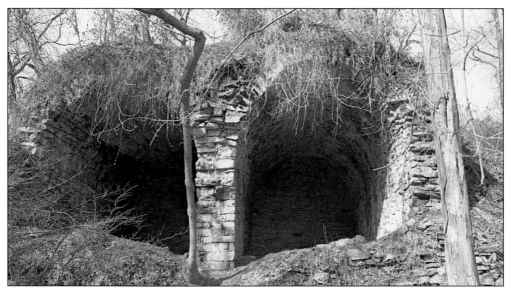

These two large arched bays set into the hillside southwest of the Leiper House are thought to be the remnants of an early tobacco "sweating" house, which sped up the process of aging tobacco by sweating it. It is believed that the structure was later used as a root cellar for the whole village of Avondale. (Delaware County Planning Commission.)

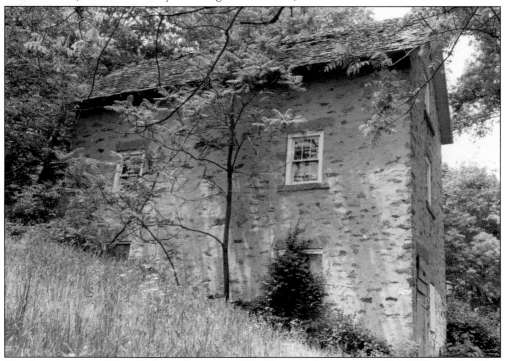

The Leiper carriage house, shown here in a 1970 photograph, is a two-and-a-half-story building made of fieldstone. According to research conducted by the county planning department, John Drew, a famous 19th century actor and ancestor of the Barrymore family, lived in the carriage house when he was the manager of the Arch Street Theatre in Philadelphia. (Nether Providence Historical Society.)

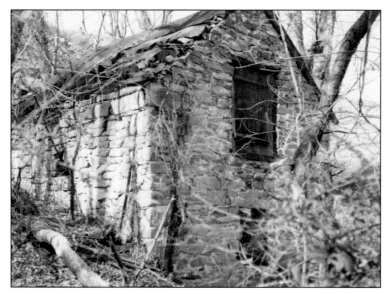

This building, called a "necessary," was an eight-hole outhouse on the Leiper estate. Built of cut stone, the entrance to the uphill side of the building was for the family, with two standard and two low holes. The four-hole downhill side of the outhouse was for the servants, who used a ladder for access. The building still stands today. (Nether Providence Historical Society.)

The "smokehouse/springhouse" was located downhill from the Leiper House. It was built of fieldstone and had a tin roof and planked doors. The top part of the structure was used for smoking meat, and the bottom part had a trough for natural spring water to keep items cool. The structure is still standing and is visible from Avondale Road. (Nether Providence Historical Society.)

The Leiper barn, shown here in 1970, was also demolished to make way for the Blue Route. The barn measured 41 by 31 feet, which was bigger than Thomas Leiper's mansion in Avondale. The land where the barn was located is now used as a parking lot for the Leiper House. (Nether Providence Historical Society.)

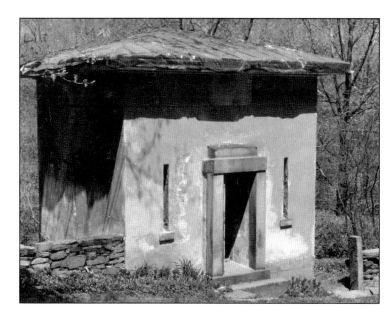

Thomas Leiper built what is commonly thought of as the first private bank in America. Pictured here in 1970, this building (called a "safety") is said to have held federal funds after the British invaded Washington, D.C., during the War of 1812. Leiper also used the safety to keep the mill's payroll and important business papers. (Nether Providence Historical Society.)

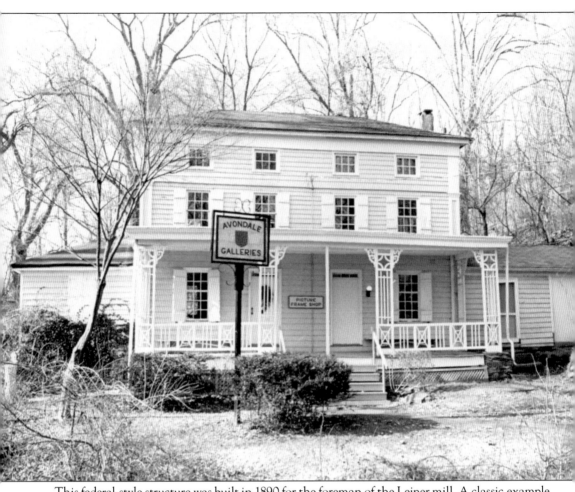

This federal-style structure was built in 1890 for the foreman of the Leiper mill. A classic example of middle class architecture of the period, the building was later used as an art and framing studio by descendants of the Leiper quarry overseers. Today the building is a private residence. (Delaware County Planning Commission.)

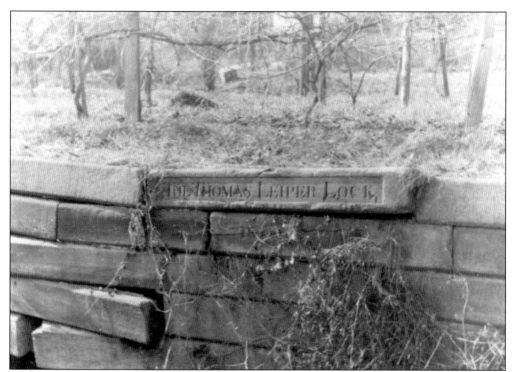

Getting his products to market was a challenge for Thomas Leiper because transportation in the area was so poor at the time. In 1791, Leiper requested permission from the Pennsylvania State Legislature to construct a canal along Crum Creek to transport his goods. The request was denied. It was not until 1824, the year before Leiper died, that the state legislature finally granted permission for him to build the canal. In 1828, Leiper's son, George, finished the canal, which ran from the village of Avondale to a point near present-day Macdade Boulevard. (Nether Providence Historical Society.)

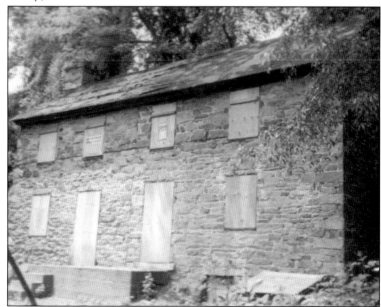

This duplex, which is no longer standing, was used as housing for Thomas Leiper's mill workers. The house was located on Avondale Road along Crum Creek backing up to a stone hillside. The house was razed in the early 1970s for construction of the Blue Route. (Thomas Hibberd.)

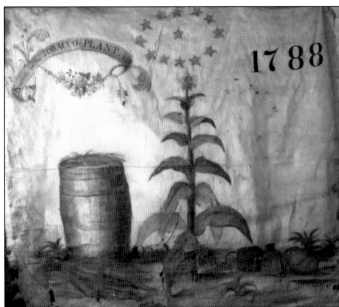

This 6-foot silk banner was carried by Thomas Leiper in a procession in Philadelphia on July 4, 1788, to celebrate the ratification of the U.S. Constitution. The banner, which was accidentally discovered in the New England attic of two of Leiper's descendants, is thought to be the only surviving banner used in the procession. (Nether Providence Historical Society.)

In order to better access the Village of Avondale, in 1780, Thomas Leiper laid out a road along Crum Creek that is now known as Avondale Road. The early Native Americans who lived in the area had called Crum Creek "Okehocking," which meant crooked creek. The Dutch later called it "Crumkill." The English who eventually settled this area shortened the name of the creek to "Crum." This photograph shows Avondale Road along Crum Creek as it looked in 1885. (Nether Providence Historical Society.)

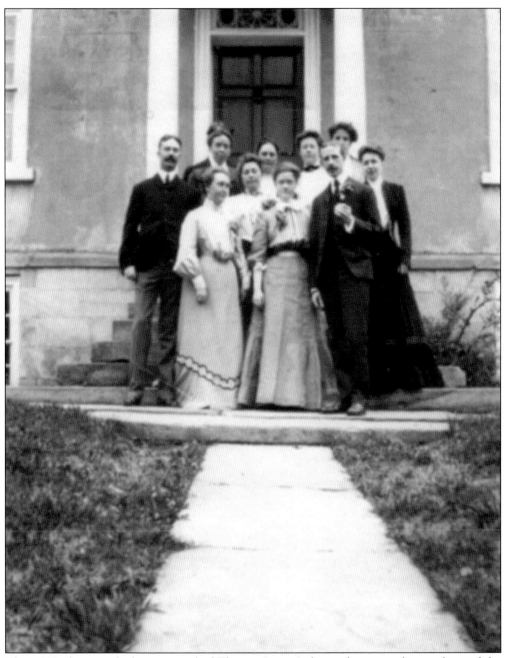

This 1903 photograph shows several of Thomas Leiper's descendants standing in front of the front entrance to the Leiper House. The house was rescued from demolition for the Blue Route through the joint efforts of Historic Delaware County, Inc. and Nether Providence Township. It is now maintained by the Friends of the Leiper House and Nether Providence Township. (Thomas Hibberd.)

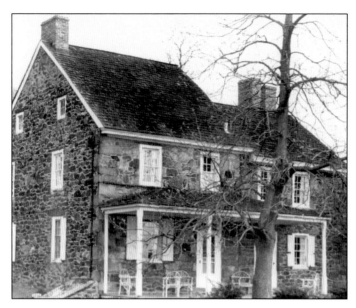

The oldest section of this house was built in 1728 by John Sharpless III, who was a descendant of one of the first Nether Providence settlers, John Sharpless. The property remained in the Sharpless family until 1872, when one of the Sharpless daughters married T. Chalkley Palmer, who then purchased the farm from her family. The 88-acre farm was later rented to the Crystle family who used the property as a dairy farm. (Nether Providence Historical Society.)

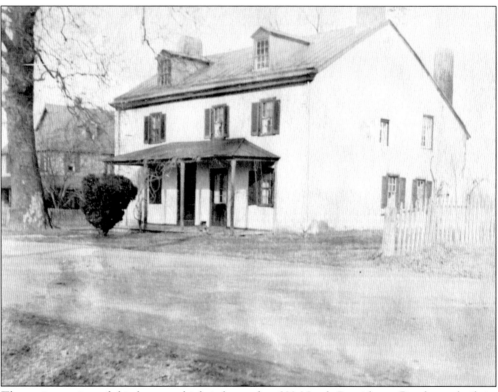

The main portion of this house, which is located at 322 North Providence Road, was built in 1704 by James Sharpless. The property, known as Wisteria, was later acquired in 1820 by Squire Thomas Afflick, who was a local justice of the peace and who was said to have occasionally held court at this location. From 1820 until 1870, Squire Afflick also ran a slaughterhouse on this property. The house, which is pictured here around 1907, is privately owned today. (Nether Providence Historical Society.)

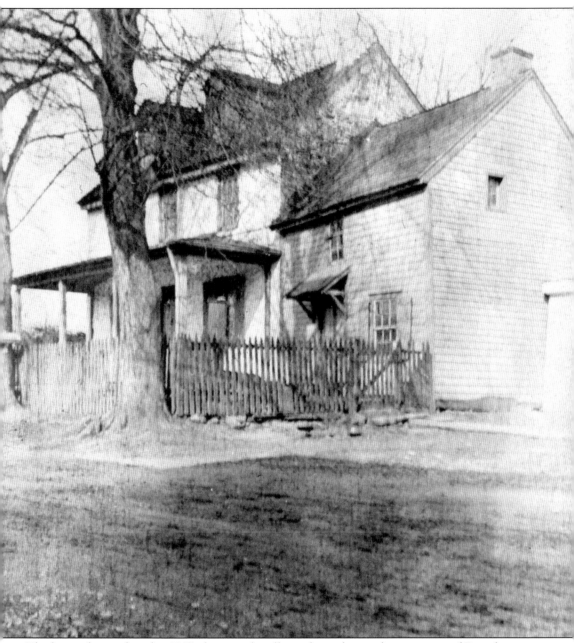
The house depicted in this 1907 photograph still stands on the northwest corner of Providence and Brookhaven Roads, an intersection commonly referred to as Hinkson's Corners. The man who owned the house in 1907, Ezekiel Norman Jr., was said to have been born in the house in 1833. According to Norman, the house was already "old" when his father bought it from the Vernon family in 1813. (Nether Providence Historical Society.)

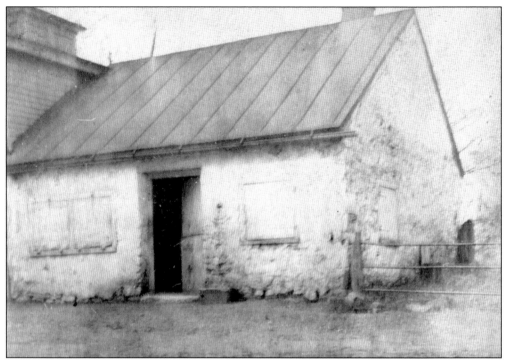

A blacksmith/wheelwright shop, shown here in 1907, was built by James Hinkson in 1799 at the northwest corner of Providence and Brookhaven Roads. The building was sold to Ezekiel Norman Sr. in 1813, along with the house that stood next to it plus 5.5 acres of surrounding land. Around 1936, the property was converted to a wrought iron and antique reproduction shop. (Nether Providence Historical Society.)

This picture shows the old Ezekiel Norman home and blacksmith/wheelwright shop as they looked in 1966 after the structures were converted into a private home and detached garage. The structures are still in use as a home and garage today. (Nether Providence Historical Society.)

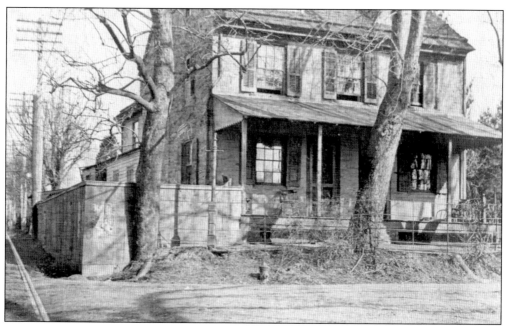

The land on which this house is built was originally part of the early Vernon land grant. The oldest section of the home, which was owned by wheelwright James Hinkson, is thought to have been built in 1737. The house was renovated and expanded in 1799, and was used as a store for 60 years. In the 1880s, the building was turned into a summer resort. Modern restoration joined the home, store, and stables into one private residence, as it remains today. (Nether Providence Historical Society.)

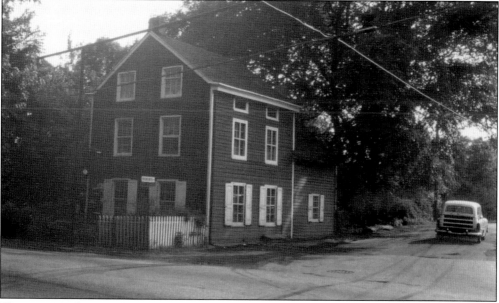

This is a 1964 photograph of the Sweeney family's house at the corner of Providence and Brookhaven Roads. The house was torn down when the roads were widened to accommodate modern traffic. A ranch-style home was later built on the property and remains today. (Nether Providence Historical Society.)

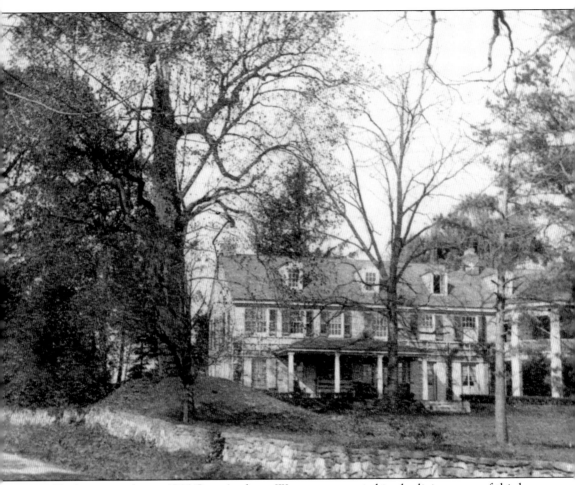

Tradition says that in 1766 Gen. Anthony Wayne was married in the living room of this house located at 410 North Providence Road. After the Battle of Brandywine in 1777, it is believed that the property was used as an American dressing station. The home was owned in the early 19th century by Rev. Alvin Parker, who briefly ran a school at the property. In 1919, the property was sold to Paul Sharpless. (Nether Providence Historical Society.)

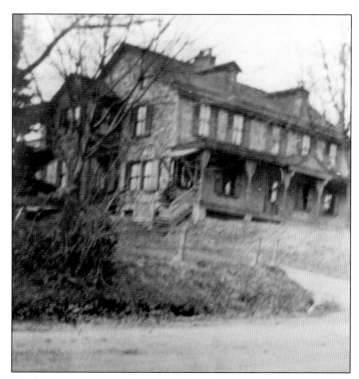

This property at 403 N. Providence Road, shown here in 1849, is though to have been built as a private residence, but was soon converted to an inn called the "Briggsville Inn," named after its owner, Isaac Briggs. It is generally considered the oldest inn in Nether Providence Township. (Media Historic Archives Commission.)

This 19th century photograph shows Beatty Road as it approached Crum Creek. On the left is 603 Beatty Road, which was built in 1760 and known as the Sycamores. It is possibly connected to the Beatty family, whose edge tool factory was located just north of the home on Crum Creek. In 1907, the house was owned by E. A. Martin, who added porches and a frame wing. The house was used by the "debutante set" for dances and social gatherings from the 1920s through the 1950s. The house is still in use. (Delaware County Institute of Science.)

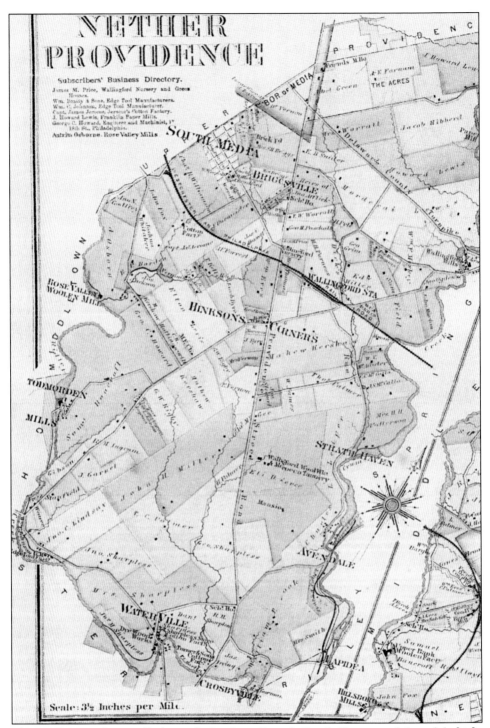

Hinkson's Corners, Briggsville (named after Isaac Briggs), Strath Haven, and Avendale [sic] are all marked on this 1870 map of Nether Providence Township. On the map, Providence Road is referred to as "Providence Street Road," and Baltimore Pike is called the "Delaware County Turnpike." (Nether Providence Historical Society.)

Two

THE GROWTH OF MANUFACTURING

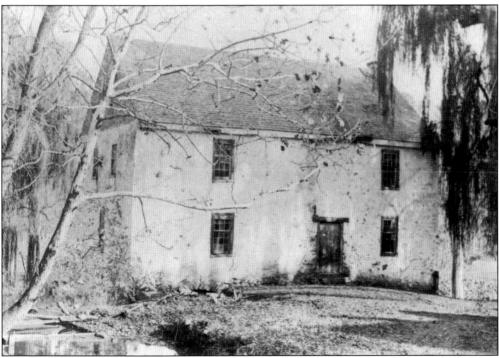

In 1764, Daniel Sharpless operated a sawmill on the north bank of Ridley Creek, west of Waterville Road. A gristmill was added in 1815, and it was later turned into a cotton and woolen factory. In 1845, the mill was destroyed by fire but was rebuilt by John M. Sharpless and operated until 1875. (Nether Providence Historical Society.)

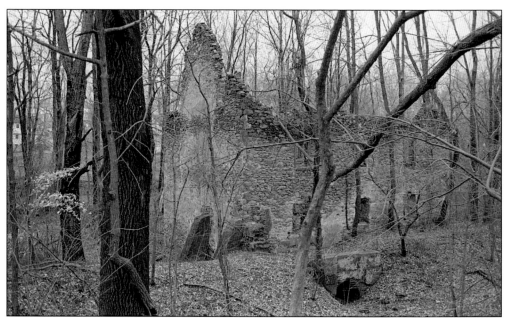

In 1810, a slitting and rolling mill was established at this site about a quarter mile east of Brookhaven Road on Waterville Road. In 1843, the mill was damaged by a flood; it was turned into an edge tool factory by Robert Beatty in 1853. In 1870, John Dutton transformed the property into a milling and tool factory. By 1935, the mill, then known as "Jowabick Mills," was abandoned. The ruins, pictured here in 1983, are all that remain of the mill. (Delaware County Planning Commission.)

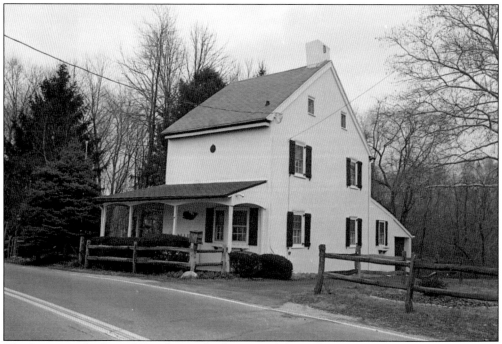

This house was built in 1793 to house the foreman of the mill complex on Waterville Road. An old farm bell was located east of the house, as was a millrace and some old ruins. The building remains a private residence today. (Delaware County Planning Commission.)

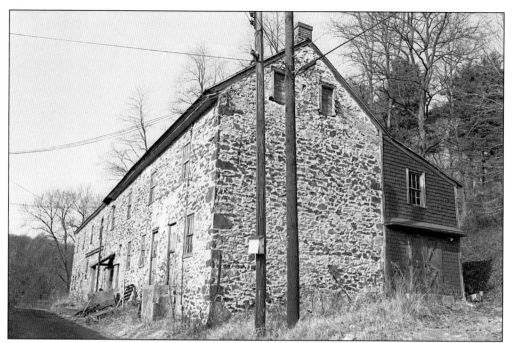

This is a two-story fieldstone workers' tenement building located at Sackville Mills on Brookhaven Road. Built in 1797 by Jacob Benningham as a carding factory, the mill was also known at times as Lower Bank Mills, Crooks' Mills, Todmorden Mills, and Columbia Mills. It was once one of the largest mill centers in the area. After the mill closed in 1992, the old mill buildings were torn down to make way for the "Mills at Rose Valley," an upscale housing development. (Delaware County Historical Commission.)

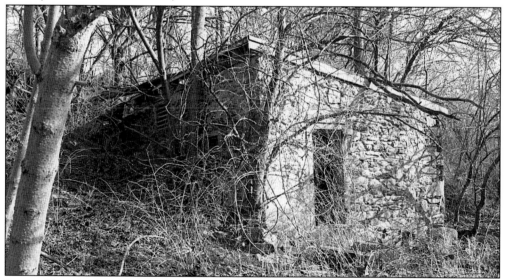

Pictured here is the old springhouse at Sackville Mills. In 1934, the mills suffered an anthrax outbreak, which was caused by diseased, imported animal hair used at the factory. On January 3, 1934, the children who lived in the mill village were evacuated. On January 27, 1934, all of the workers' houses were closed and the entire mill village was permanently evacuated. (Delaware County Planning Commission.)

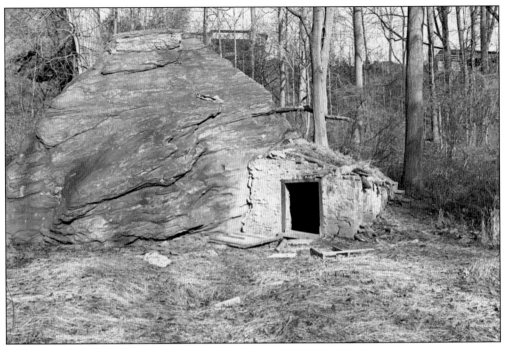

Shown here is the Sackville Mills incinerator. Most of the outbuildings, homes, and the mill's church were destroyed by fires in 1932 and 1936. Although World War II brought new life to Sackville Mills, by 1958, most of the mill operations were moved to North Carolina. Slowly over the next several decades, more of the mill departments were moved south. In 1992, the mill was permanently closed. (Delaware County Planning Commission.)

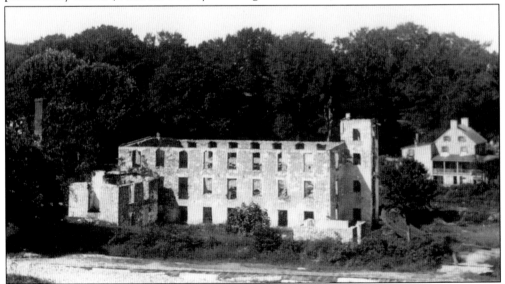

In 1776, Thomas Leiper built a powder mill along Crum Creek. In 1779, Leiper added a snuff mill to the property and later added a blade mill and stone quarries. By 1825, he had also added a paper mill, a stone-cutting mill, an oyster-crushing mill, and a textile mill. Shown here is Leiper's old paper mill on Avondale Road as it stood in 1910. Avondale Mills continued production until the Great Depression. (Nether Providence Historical Society.)

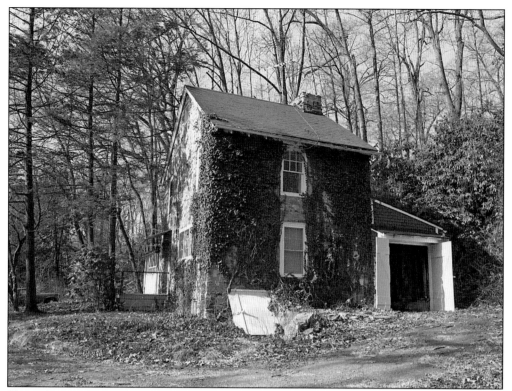

Shown here is the north facade of a house located at 405 East Rose Valley Road that was built in 1824 for the foreman of Thomas Leiper's blade mill. At its height, the mill is said to have had a yearly output of 200-dozen scythes and straw knives. Leiper's son, George, took over management of the mill in 1825. (Delaware County Planning Commission.)

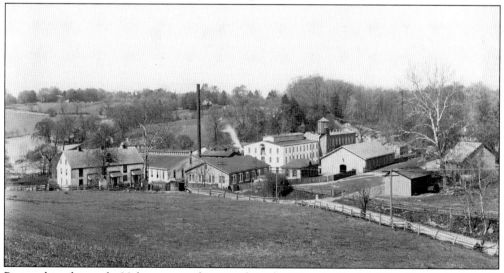

Pictured in this early 20th century photograph is the Victoria Plush Mills. Although the mill structures are all located across Crum Creek in Springfield Township, many of the mill workers lived in tenement housing on the Nether Providence side of Crum Creek at the foot of Plush Mill Road. (Delaware County Institute of Science.)

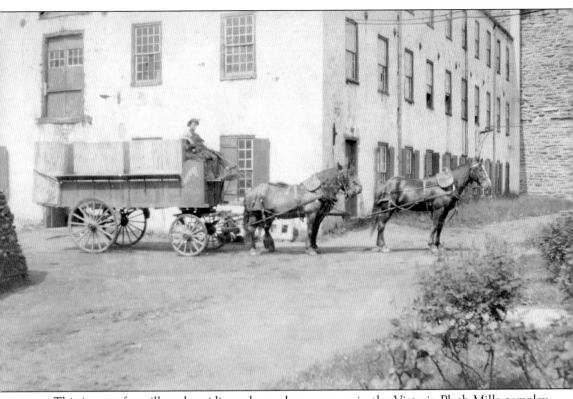

This image of a mill worker riding a horse-drawn wagon in the Victoria Plush Mills complex located on Baltimore Pike was taken on June 15, 1907. The mill was in operation until the 1930s. (Delaware County Institute of Science.)

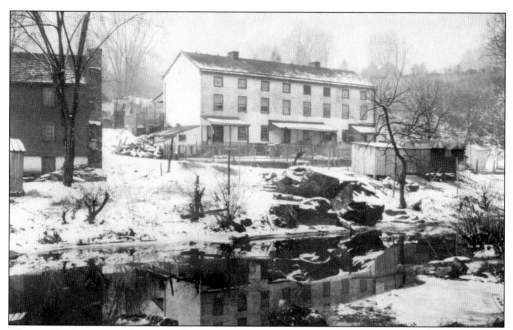

The workers' tenement house and outbuildings at Victoria Plush Mills, which were located along Crum Creek in Nether Providence Township, are pictured in this early-20th-century photograph. (Delaware County Institute of Science.)

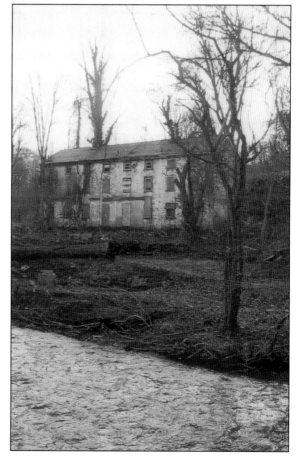

This picture shows the Victoria Plush Mills tenement house in 2004 before it was torn down. As the picture illustrates, by the time the house was torn down, it was dilapidated and abandoned. (Nether Providence Historical Society.)

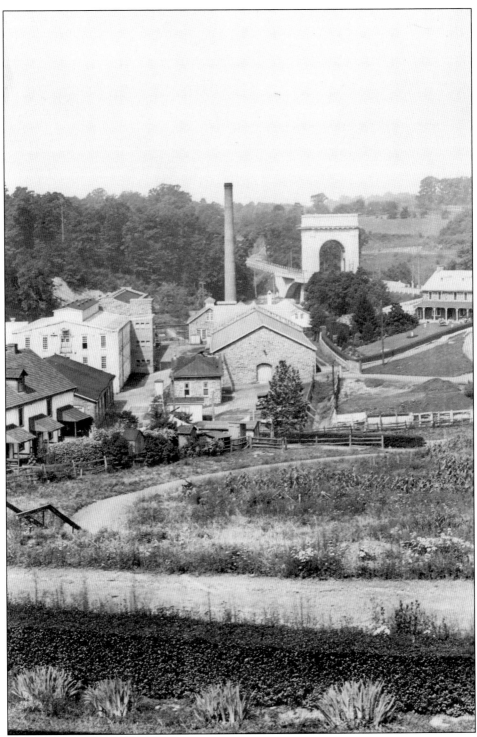

This view of Victoria Plush Mills looking towards Media, Pennsylvania, shows the workers' tenement house on the left, and in the distance, the Memorial Bridge archway, a familiar landmark at the Baltimore Pike entrance to Nether Providence Township. (Delaware County Institute of Science.)

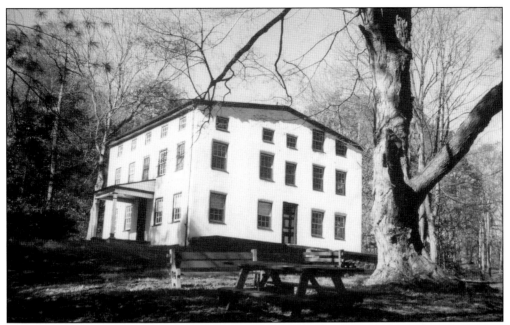

Around 1840, J. Howard Lewis, the owner of the Victoria Plush Mills, built this home on a 106-acre estate in Nether Providence Township on the north side of Baltimore Pike overlooking the mills. Lewis's estate later became part of Smedley Park. His house, pictured here in 1981, is presently occupied by Pennsylvania State University's Cooperative Extension of Delaware County. (Nether Providence Historical Society.)

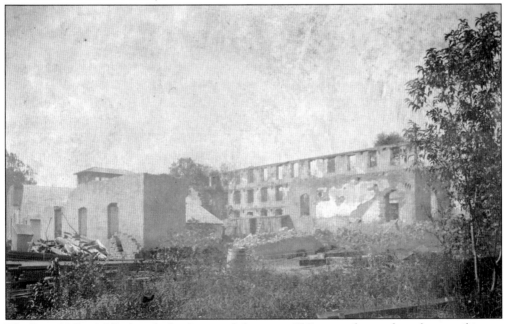

The Rose Valley Mills, bought by Antrim Osborne in 1861, manufactured woolens until it was destroyed by a fire in 1885. This image shows the burnt-out mill in 1896. Rose Valley was part of Nether Providence until 1923 when it became a separate municipality. (Delaware County Institute of Science.)

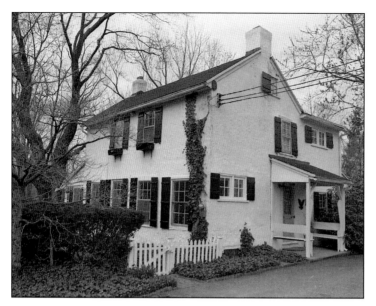

This house is located in a row of five duplex houses along Willow Lane. They were built after Isaac Briggs opened a brickyard in 1819 adjacent to the homes. Willow Lane was known as "Rotten Row" because of the bad bricks that Briggs had used to build the houses. (Delaware County Planning Commission.)

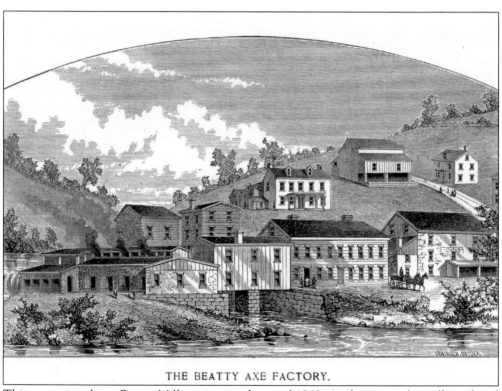

THE BEATTY AXE FACTORY.

This engraving shows Beatty Mills as it existed around 1860. At that time, the mill employed 28 men with an annual labor cost of $6,720 and produced 5,000 each of axes, hatchets, cleavers, drawing knives, and chisels with an aggregate value of $21,500. The property was sold to J. Howard Lewis in 1882. (Nether Providence Historical Society.)

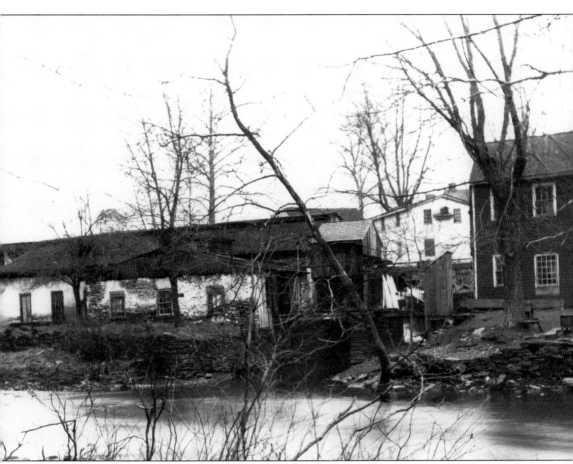

This 1889 photograph shows the Beatty Edge Tool Factory, or "Beatty Mills" as it was sometimes called. The mill, which sat along Crum Creek at the foot of Beatty Road, began producing farm and carpentry equipment in 1828. The mill was greatly expanded around 1860 and began to produce great quantities of tools. The light-colored building in the background is the only remaining building from the mill. (Media Historic Archives Commission.)

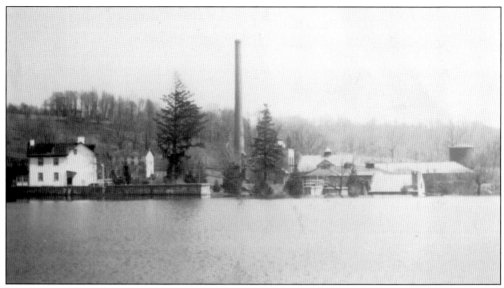

The Springfield Water Company pumping station, pictured here in 1940, sits where the Beatty Tool Factory was once located. The Beatty property was sold in 1882 to J. Howard Lewis, who then sold it to the Springfield Water Company in 1892. The Philadelphia Suburban Water Company operates at the site today. (Nether Providence Historical Society.)

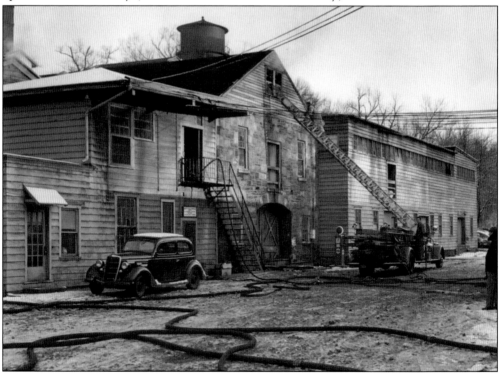

This 1947 photograph was taken at Franklin Paper Mills, which was situated on Crum Creek north of what is now Smedley Park. The mill was operated by John Lewis from 1833 until 1868, and then by J. Howard Lewis and his sons from 1868 until after 1900. The mill was later called the Paper Products Manufacturing Factory and continued to operate until the late 1970s. (Thomas Hibberd.)

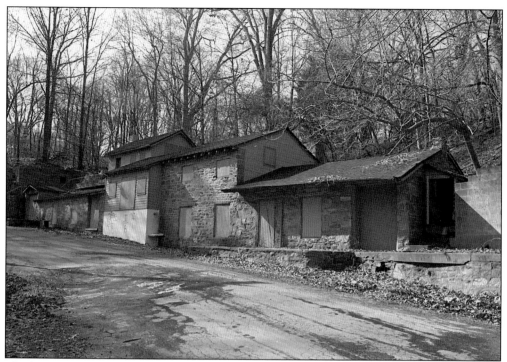

The former Cleftrock Spring Water Company, owned by Wentworth Simmons, provided bottled water from around 1945 through the 1960s. The ruins of the bottling company are still visible today along Avondale Road just past the U.S. Interstate 476 bridge. (Delaware County Planning Commission.)

Wilson Coal and Supply Company, shown here in 1964, was founded in 1926 by 28-year-old Marvel Wilson Sr. He built the company's headquarters in Wallingford, Pennsylvania, on a tract of land he purchased from the Pennsylvania Railroad. The company is still located at the same site. (Wilson Oil Company.)

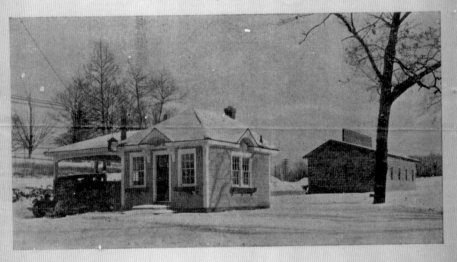

Shown here is a 1927 advertisement for the Wilson Coal and Supply Company. In 1933, Marvel Wilson Sr. bought a used oil truck, and the company started making heating oil deliveries. By the late 1970s, the company was delivering more than eight million gallons of oil a year. (Wilson Oil Company.)

Three
EDUCATING THE CHILDREN

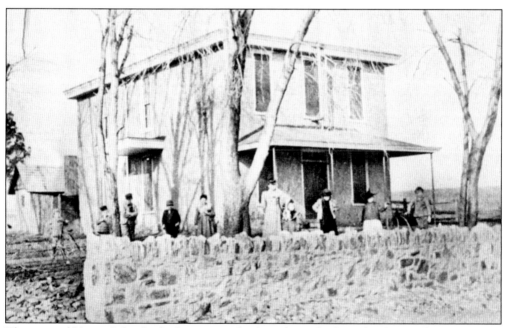

The original Union School, which is reported to have been the first school in Nether Providence Township, was built near Hinkson's Corners in 1810 on a lot purchased from Benjamin Holston. In 1866, the building was partially torn down, and a new building put in its place. Today the building is a private residence and sits across from Strath Haven High School's entrance on Brookhaven Road. (Nether Providence Historical Society.)

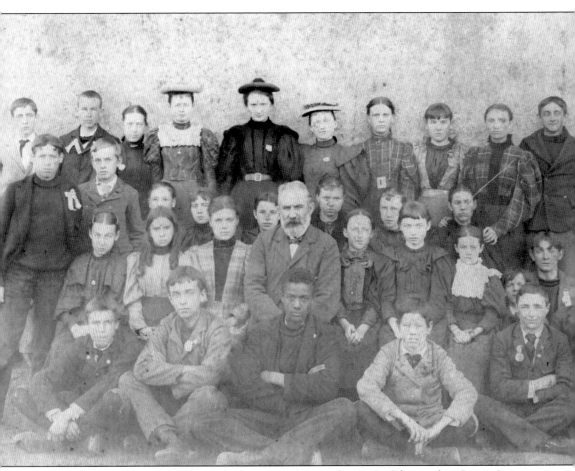

Shown here is a Union School class picture taken in the 1890s. The teacher, James Sweeny, is sitting in the middle of the picture. This school was attended by children of local mill workers and laborers. Most of the wealthier residents in the area sent their children to boarding schools or had them privately tutored. (Nether Providence Historical Society.)

In 1812, the Society of Friends School was built at the intersection of Beatty Road and Baltimore Pike. The school was closed in 1856, and the building was later used as a residence. This 1941 photograph shows the building being demolished to make way for a new Howard Johnson's restaurant, which has since been torn down. (Media Historic Archives Commission.)

The Pleasant Hill School was built in 1841 on a lot purchased from Henry Sharpless. The school, which was located at the intersection of Harvey and Providence Roads, was initially a one-story building. In 1870, the old school was torn down and replaced with a new two-story building and a playground. The school was used until 1914. It was razed in the 1920s. (Nether Providence Historical Society.)

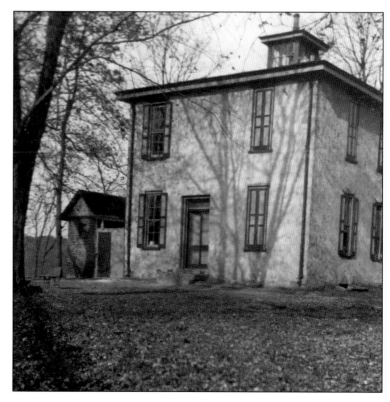

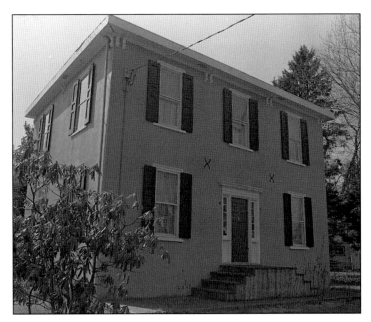

The Briggs School was built around 1860 on a triangular lot at the corner of Shepherds Lane and Providence Road. The school was built by Isaac Briggs for the children of his factory workers. It was located right down the street from Rotten Row where many of his workers lived. The school was remodeled as a private residence in 1875. It is still used as a private residence today. (Delaware County Planning Commission.)

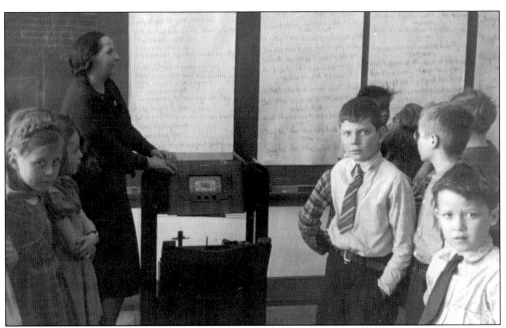

In 1901, the original Wallingford School was built where the current Wallingford Elementary School stands today. Originally a school for Thomas Allen's Wallingford Mill, Wallingford Elementary School later became the primary public elementary school in the area. The original wood school burned down in 1930 while the new brick school was being built. (Charles Morris.)

This 1923 image looks west on Copples Lane towards Providence Road. The empty field beyond the trees was later the location of Nether Providence High School, which was built in 1970. In 1983, Nether Providence High School and Swarthmore High School merged to become Strath Haven High School. (Nether Providence Historical Society.)

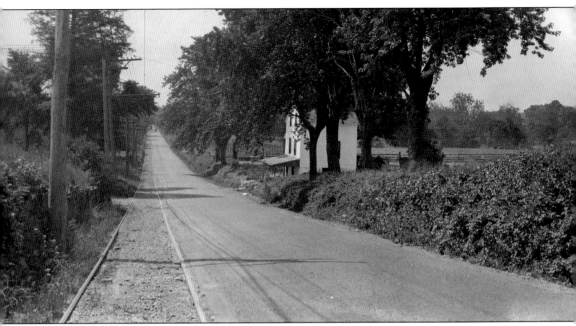

This photograph, also taken in 1923, looks south on Allen's Hill on Providence Road, just past Copples Lane. The old house on the right side of Providence Road was once part of the Allen Estate. The house has since been torn down. (Nether Providence Historical Society.)

The Nether Providence Junior-Senior High School, which was built in the 1920s on Allen's Hill, offered secondary school education (grades 6–12) to the children of Nether Providence Township. The school later became Nether Providence Middle School. In 1991, grades six, seven, and eight of the Swarthmore-Rutledge School merged with Nether Providence Middle School to become Strath Haven Middle School. (Charles Norris.)

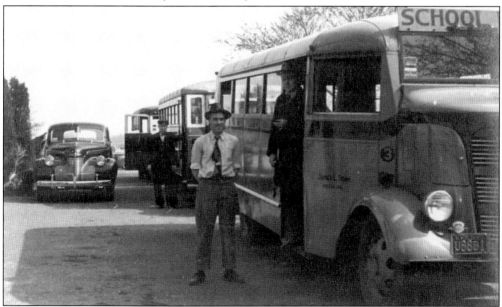

The student population of Nether Providence grew during the first part of the 20th century as the mills began to close. In 1939, the Garden City School was expanded, and several additions were made to the Wallingford Elementary School. Some of the student overflow attended the South Media School, and by 1944, there was a kindergarten at the Helen Kate Furness Free Library. Around this time, the township began to use school buses like the ones depicted in this photograph to transport the students to and from school. (Charles Morris.)

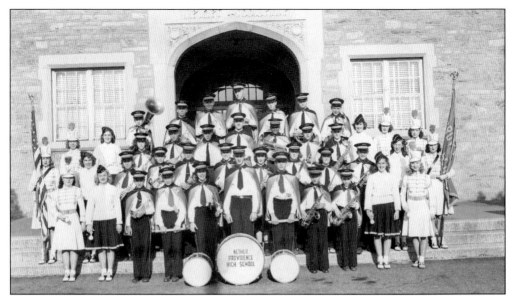

The Nether Providence High School marching band is pictured in this 1947 photograph. The band is standing in front of the entrance to the school, which faces Providence Road. In 1953, a new auditorium, gymnasium, and additional classrooms were built at the school. (J. Mervyn Harris.)

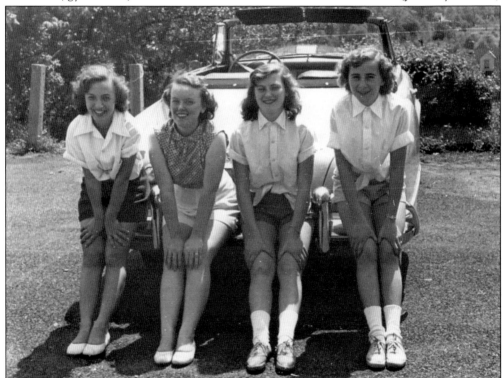

This photograph was taken on May Day 1951 in a parking lot where the new middle school now stands. The lot at the corner of Copples Lane and Providence Road was purchased by the school district in 1945 for additional parking. Pictured are, from left to right, Jeanette Ketrie, Betty Stevens, Alice Taylor, and Joan Seih. (J. Mervyn Harris.)

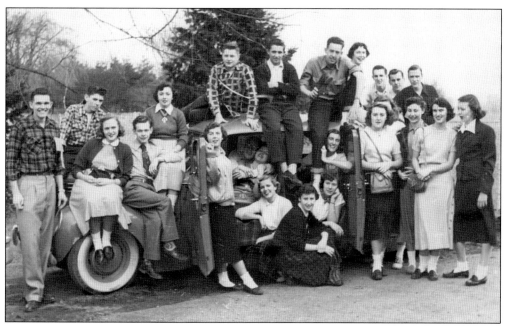

This senior class photograph was taken on February 8, 1952, at Nether Providence High School. J. Mervyn Harris (fourth from the left) is shown relaxing on the hood of a car with some of his classmates. (J. Mervyn Harris.)

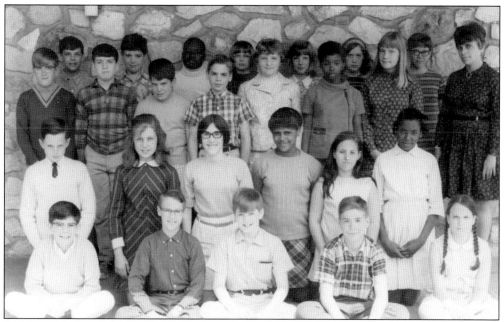

Freema Nichols's sixth grade class at the Summit School is pictured in this class photograph taken in the late 1960s. The Summit School, which was located on Plush Mill Road, was closed in 1975 due to declining population. The building was later used by the Delaware County Intermediate Unit for special education. (Freema Nichols.)

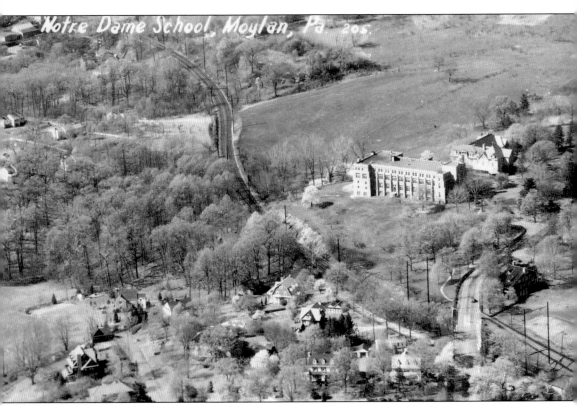

Although this photograph says the Notre Dame School is located in Moylan, Pennsylvania, which is in Nether Providence Township, the school was actually located just across the border in Upper Providence Township. The school was built as a convent prior to 1910 for the sisters of Notre Dame de Namur. It opened as a boarding school for girls in 1926, and joined the archdiocese in 1935 as a Catholic high school. The school was closed in 1981, and the building was sold to Pennsylvania Institute of Technology in 1982. (Nether Providence Historical Society.)

Four

THE DEVELOPMENT OF COMMUNITY SERVICES

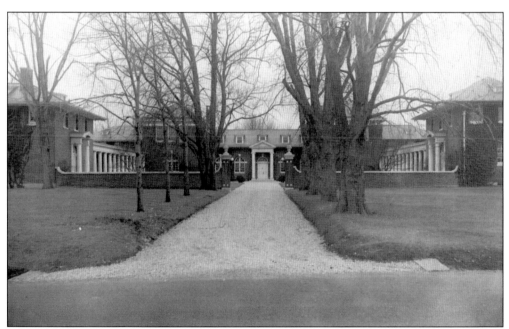

The Philadelphia Orphanage was initially founded by Rebecca Gratz and Sara Rals at 18th and Cherry Streets in Philadelphia. In 1875, the institution was moved to 63rd Street and Lansdale Avenue. In 1905, the orphanage was moved to the building shown here in Wallingford, Pennsylvania, on Providence Road near Hinkson's Corners. (Nether Providence Historical Society.)

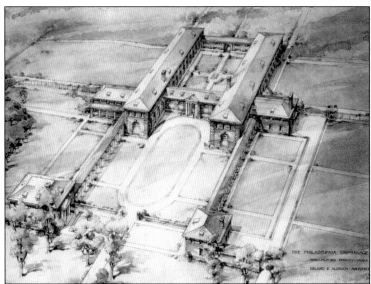

Shown here is a 1903 architectural drawing of the Philadelphia Orphanage by architects Delano and Aldrich of New York. The orphanage was closed in 1965 and reopened in 1969 as the Wallingford Convalescent, Rehabilitation, and Nursing Center. (Nether Providence Historical Society.)

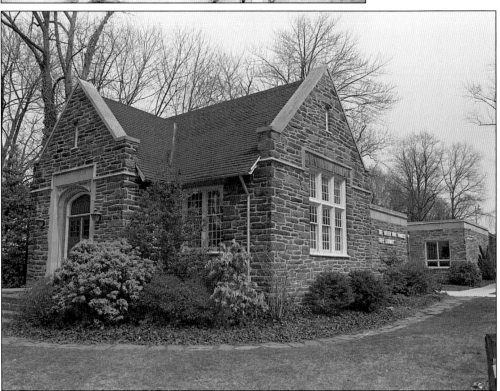

The Helen Kate Furness Free Library was founded in 1902 by a group of Nether Providence citizens as the Horace Howard Furness Free Library, named after a famous Shakespearean scholar whose estate, Lindenshade, was located in Nether Providence Township. When Dr. Furness died in 1912, he bequeathed $5,000 to the library on the condition that the library's name be changed to the Helen Kate Furness Free Library to honor his wife. In 1913, Dr. William Henry Furness III, a son of Dr. and Mrs. Furness, conveyed to the library an acre of land on which a native stone building (shown here) was constructed in 1916. (Delaware County Planning Commission.)

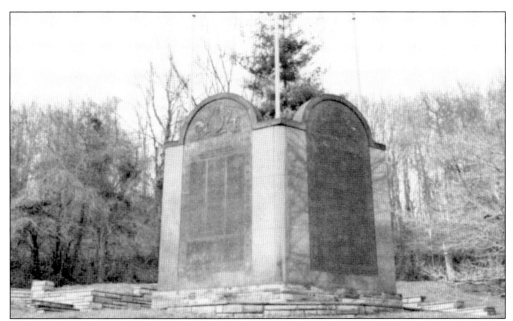

When the Memorial Bridge on Baltimore Pike was razed to widen the highway in the 1950s, the bridge's bronze tablets with the names of the local residents who died in World War I were preserved. In the early 1990s, the tablets were made into a war memorial that was placed at the entrance to Smedley Park. (Nether Providence Historical Society.)

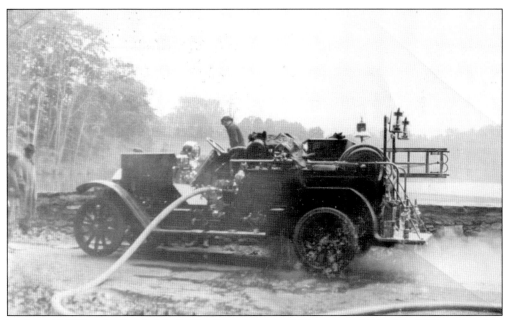

In the mid-1920s, the South Media Fire Department, which was established in 1922, replaced its horse-drawn steam pumper with this 1923 American–La France four cylinder, rotary gear 500-gpm pumper at a cost of $9,000. Nether Providence's first fire marshal, Robert F. Foltz, was not appointed until 1967. (South Media Fire Department.)

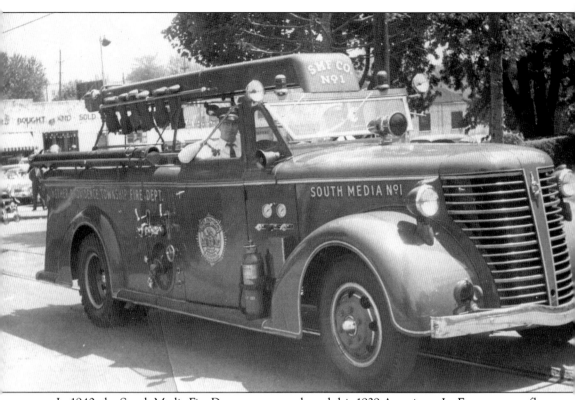

In 1940, the South Media Fire Department purchased this 1939 American–La France centraflow pumper, which the department used for more than 25 years. It was kept at the fire station until 1968, when it was finally stripped and disposed of. (South Media Fire Department.)

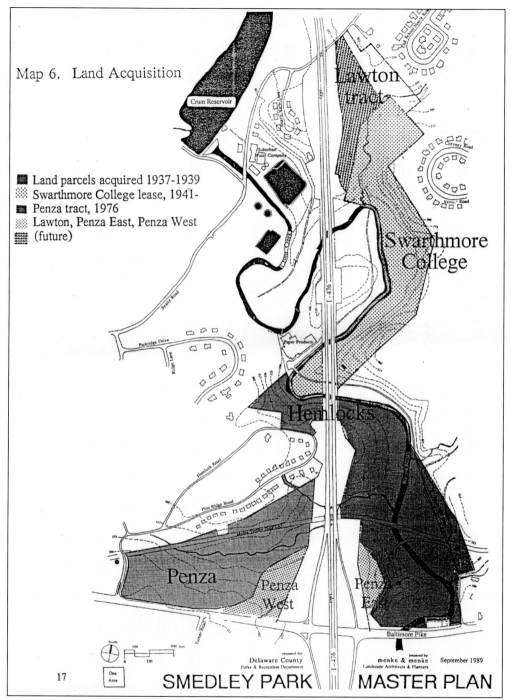

This 1989 map shows the master plan for Nether Providence's Smedley Park, which was named after Samuel L. Smedley, the founder of Delaware County's Parks and Recreation Board. The 1840 estate house of J. Howard Lewis is still located in the park. The old Lewis house is now Penn State's Cooperative Extension of Delaware County, an organization that operates numerous agriculture, horticulture, and nutrition programs. (Nether Providence Township.)

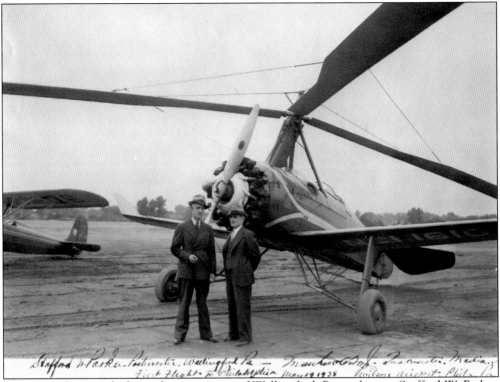

This 1938 photograph shows the postmaster of Wallingford, Pennsylvania, Stafford W. Parker, and the postmaster of Media, Pennsylvania, Matthew C. Fox Jr., in front of an Autogyro. On May 19, 1938, the Autogyro, which was loaded with 12 parcels of mail, took off from an aviation field located between Beatty and Turner Roads just off of Baltimore Pike. The plane never made it to its intended location, the 30th Street post office in Philadelphia, because it was unable to land on the post office's roof. (J. Mervyn Harris).

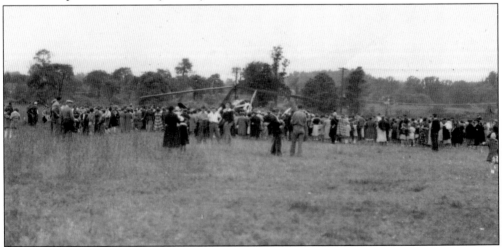

On May 19, 1938, Nether Providence and Media school students were dismissed early from school to witness the Autogyro's first airmail flight. Two high school bands played and four navy pursuit planes circled the field before take-off. The field was later developed in 1954 as Wallingford Summitt. (Thomas Hibbert.)

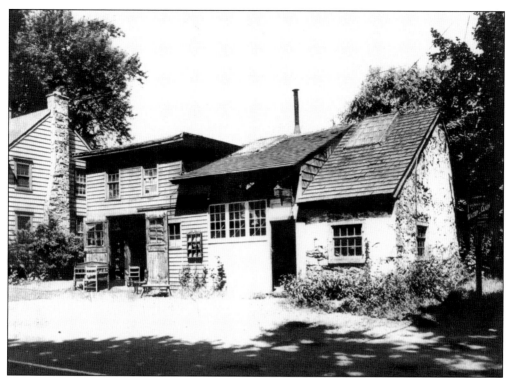

Starting in the late 1930s, township meetings and elections were held in the old blacksmith's shop at the corner of Brookhaven and Providence Roads. All township records were kept by township secretary J. Paul Palmer at his flower shop at the corner of 7th and Sproul Streets in the City of Chester. In 1953, the township, requiring more space, moved its township building to the old barn on the Sykes Estate. (J. Mervyn Harris.)

In 1952, the Nether Providence Fire Department bought this 1952 Dodge "Flexible Flyer." The fire engine was in service until 1969, at which time it was given to a volunteer fire company in Glasgow, Virginia, whose equipment had been destroyed by a hurricane. (South Media Fire Department.)

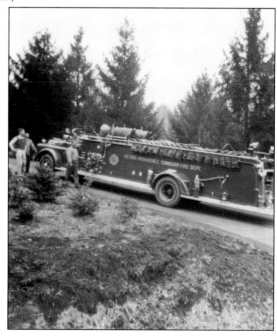

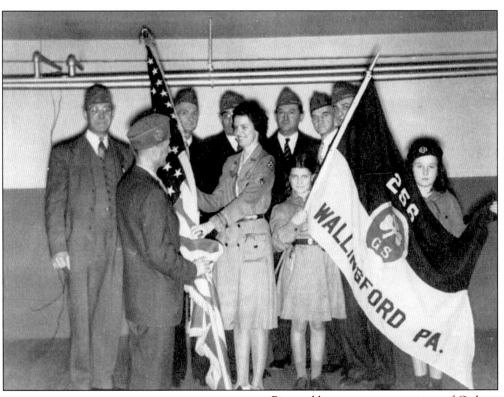

Pictured here are representatives of Girl Scout troop No. 256 of Wallingford, Pennsylvania, presenting an American flag to several retired servicemen. The Girl Scouts was founded in 1912 by Juliette Gordon. (Charles Morris.)

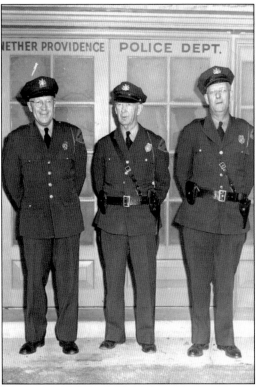

The Nether Providence Police Department was established in 1935 with one police officer, Ralph A. Howard, who served as Nether Providence's police chief for 28 years. Matthew McCarty was hired as the department's second officer in 1937. A third officer, Walter Sydnor, was hired in 1948. All three are pictured in this 1953 photograph. Shown from left to right are Matthew McCarty, Walter Sydnor, and Ralph A. Howard. (Nether Providence Historical Society.)

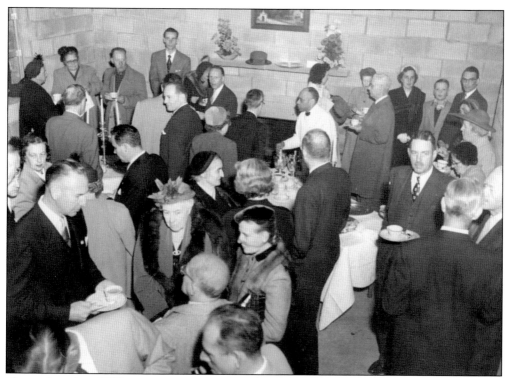

Shown here is a 1950s reception at the visitor's center of Taylor Memorial Arboretum. The arboretum was established in 1931 by a Chester lawyer, Joshua C. Taylor, in memory of his wife, Anne Rulon Gray. (Taylor Memorial Arboretum.)

Public visitation of the grounds of Taylor Memorial Arboretum started in 1952. The site of the arboretum was once part of a 1,000-acre land grant sold to John Sharpless by William Penn in 1682. From 1740 until 1882, the grounds were part of an industrial mill complex that produced lumber, grain, and textiles, among other products. (Taylor Memorial Arboretum.)

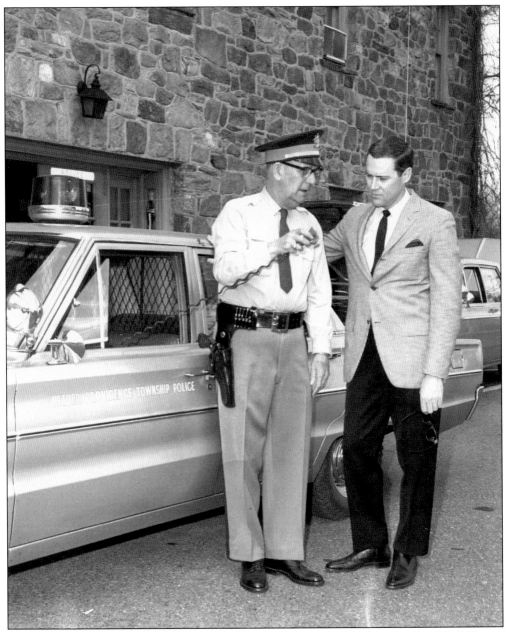
Shown in this 1967 photograph are Walter Sydnor, the township's police chief, and Bill Kuster, a weatherman at KWY-TV. They are standing at the entrance to the police station, which is located on the old Sykes estate. (Nether Providence Historical Society.)

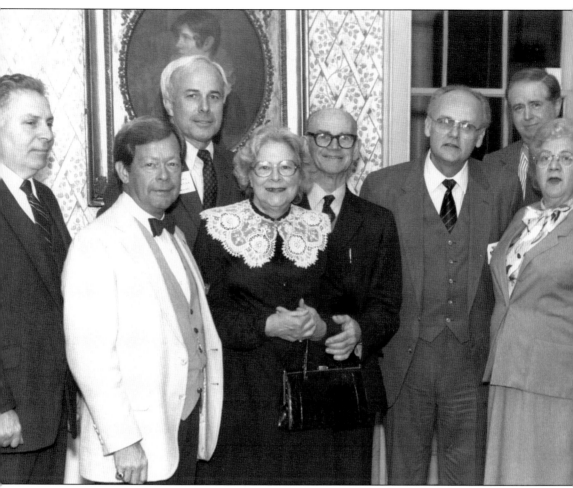

This photograph was taken at the Leiper House at a reception for the lord mayor of Wallingford, England. The reception was part of the township's tricentennial celebration in 1987. Shown in this picture are, from left to right, Eugene Monaco, J. Mervyn Harris, Dan Butler, Evelyn Revell, Hon. William Revell, Jessie Mills, Joseph Mulcahy, and Marie Hosler. (J. Mervyn Harris.)

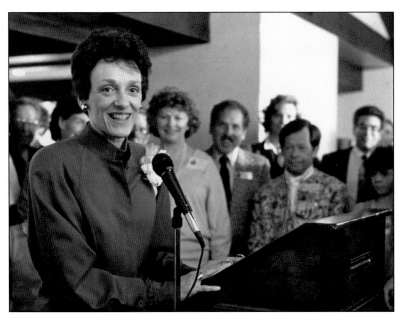

Joan Mondale was honored at a reception at Springhaven Country Club in December 1986. Mondale lived in Nether Providence before she married Walter Mondale, the 42nd vice president of the United States. (J. Mervyn Harris.)

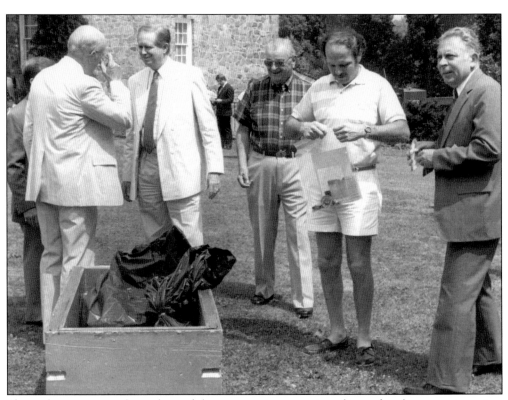

Shown here are several members of the community preparing objects for placement in a time capsule that was buried in front of the township building in 1988 as part of Nether Providence Township's tricentennial celebration. The time capsule is scheduled to be opened in 2037. (J. Mervyn Harris.)

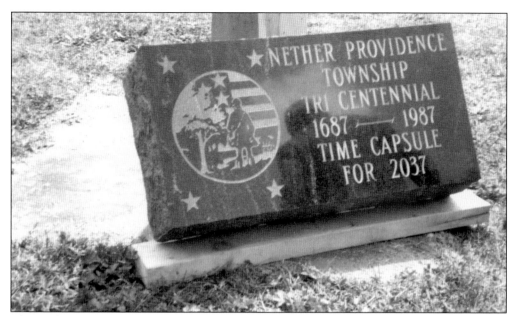
The marker for the township's time capsule is shown in this picture. Among the items placed in the capsule were license plates, school district publications, newspaper clippings, and Christmas tree seeds. (J. Mervyn Harris.)

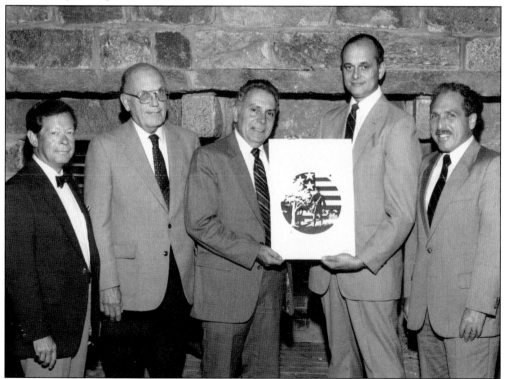
The township's tricentennial logo was proudly revealed by members of the tricentennial commission. Shown in this photograph are, from left to right, J. Mervyn Harris, William Moser, Eugene Monaco, Jim Ellis, and Stanley Kotzen. (J. Mervyn Harris.)

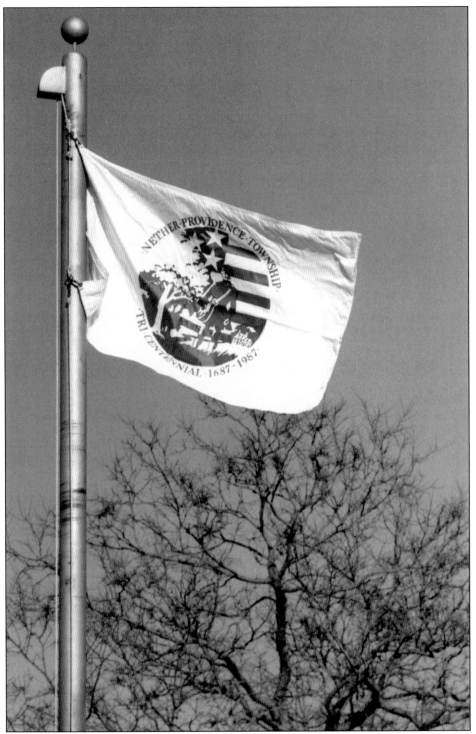
A flag with the tricentennial logo was displayed in front of the Nether Providence Township building during the tricentennial festivities. Jim Ellis, an art teacher from the local high school, designed the logo. (J. Mervyn Harris.)

Five

TRANSPORTATION

This 19th century photograph shows Beatty Hollow at the corner of Beatty Road and Crum Creek Road. A cart's wagon wheel is visible as the cart enters Old Country Bridge, presumably on its way to Springfield Township. Beatty Mills (which cannot be seen in the picture) was located to the left of the bridge along Crum Creek. (Delaware County Institute of Science.)

The horse-drawn cart in this 1903 photograph is traveling down Beatty Road towards the Springfield Water Works. To the left of the cart was Jacob Hibbert's farm, and to the right was one of the water work's buildings, which still stands in the same location. (Delaware County Institute of Science.)

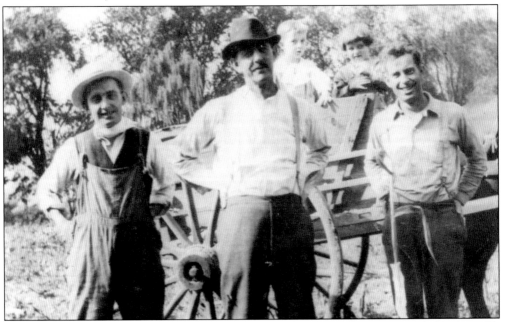

Pictured in this 1917 photograph are, from left to right, Judge William Rogers (a blacksmith), James Sharpless Rodgers (clerk of the Delaware County commissioners), John Rock (a local child), Horace C. Rogers Jr. (a local child), and Horace C. Rogers (a local carpenter). (Nether Providence Historical Society.)

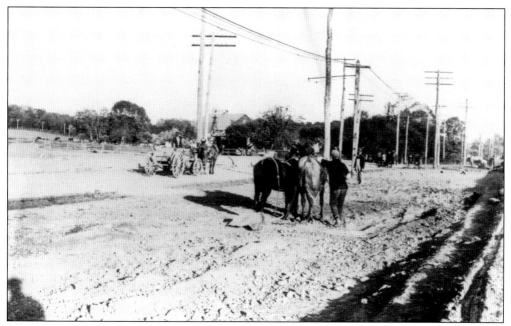

By 1913, many of the roads had been macadamized, including Providence Road and Brookhaven Road from Ridley Creek to the present-day railroad crossing. This photograph, taken in 1919, shows the groundbreaking of Chestnut Parkway. (Nether Providence Historical Society.)

This 1926 image looks south on Chestnut Parkway toward the old Waterville Bridge over Ridley Creek. The home of Townsend Sharpless and a local store are visible on the left. To the right, there is a detour sign pointing towards Chester, Wilmington, and Delaware. (Nether Providence Historical Society.)

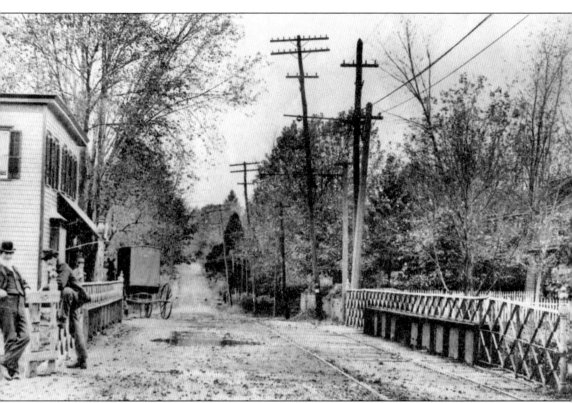

This photograph, taken around 1895, shows Providence Road heading towards Media, Pennsylvania. The men in the picture are identified as, from left to right, George Geary and Albert Geary. The building on the far left, which was used as a store at the time the picture was taken, still stands today. (Community Arts Center.)

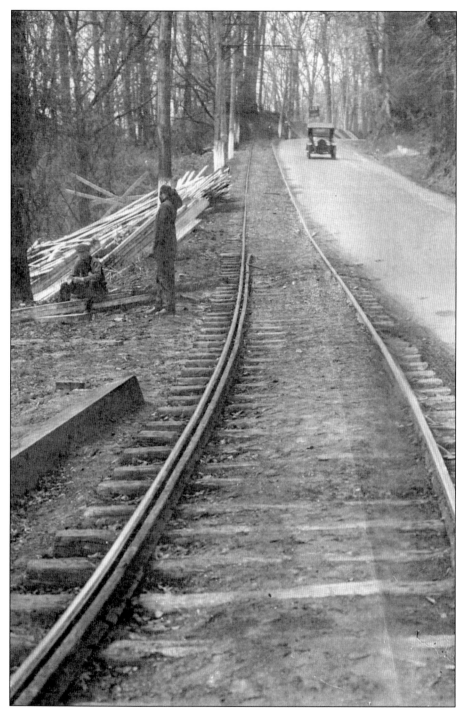

The men shown here are clearing a work site along Baltimore Pike in 1923. The trolley track in the middle of the picture was for trolleys of the West Chester Traction Company, also known as the Red Arrow Line. The line started at 69th Street and traveled through Lansdowne and Springfield Township. It then worked its way through Smedley Park at the north end of Nether Providence, ending on State Street in Media, Pennsylvania. (Nether Providence Historical Society.)

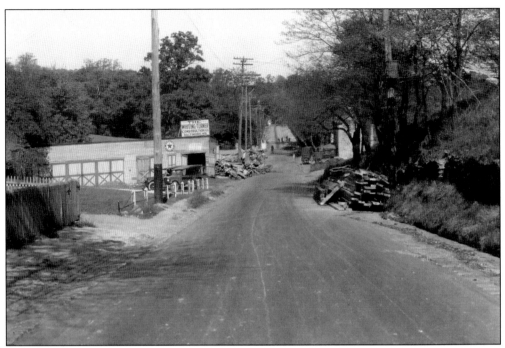

The Shoemakerville Bridge connecting Nether Providence and the City of Chester was in the process of being rebuilt in this 1925 photograph. The Whiting Turner Construction Company can be seen on the left side of the road. (Nether Providence Historical Society.)

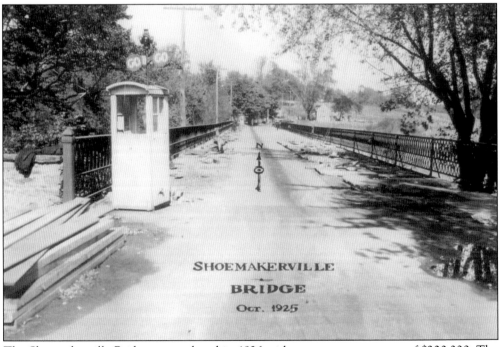

The Shoemakerville Bridge was replaced in 1926 with a new span at a cost of $200,000. The new bridge was named Gov. Printz Bridge in honor of the first governor of the Swedish Province established in Tinicum in 1643. (Nether Providence Historical Society.)

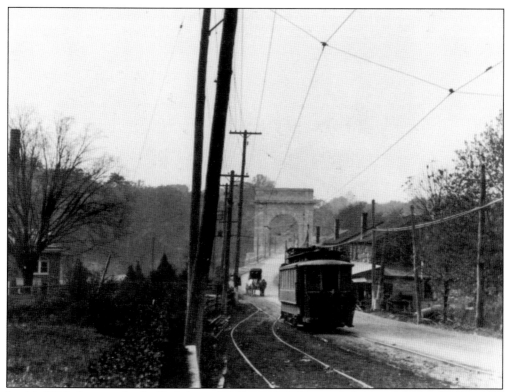

In this 1924 photograph, the Red Arrow Trolley is traveling on Baltimore Pike heading towards Nether Providence and Media, Pennsylvania. To the left of the picture is Victoria Plush Mills, and to the right is Smedley Park. In the distance is Memorial Bridge, which remained a familiar landmark until the 1950s when it was taken down to accommodate a wider highway. (Media Historic Archives Commission.)

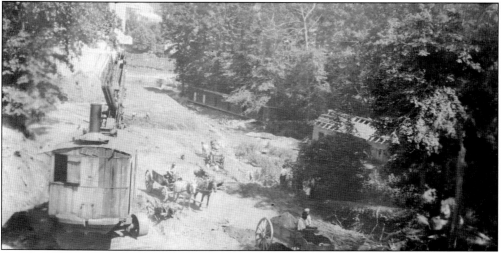

Construction of the Memorial Bridge began around 1920 after the Keystone Automobile Club president called for a replacement of the old covered bridge on Baltimore Pike. The new bridge eliminated the steep grades on the Nether Providence side. (Media Historic Archives Commission.)

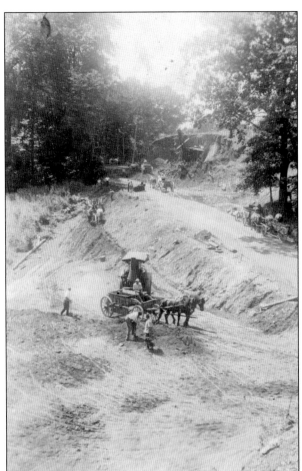

The new Memorial Bridge, which is shown here during construction, had two spans of about 120 feet each, making them the largest spans in Delaware County at the time. The 30-foot width included roadway and trolley tracks. (Media Historic Archives Commission.)

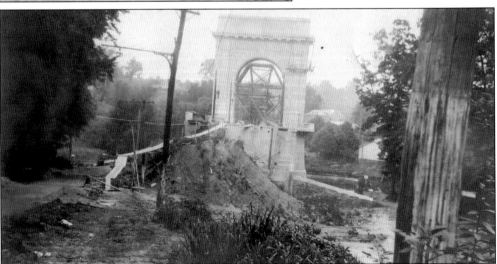

The Memorial Bridge was designed by Clarence Wilson Brazer to be a huge Triumphal Arch, dedicated to local residents who fought in World War I. Bronze tablets were placed in the interior of the arches with the names of all those who had died in the war. (Media Historic Archives Commission.)

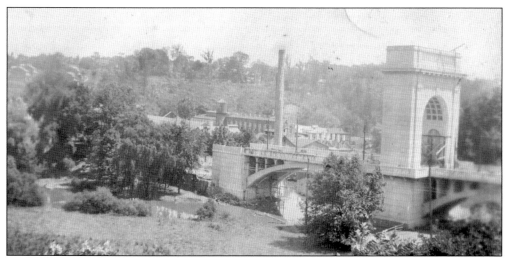

The Memorial Bridge, which is shown in this photograph looking towards Victoria Plush Mills, was officially opened on Armistice Day, November 11, 1926. When the arch was demolished in 1958, the bronze tablets were cleaned, made into a war memorial, and moved to the entrance of Smedley Park. (Media Historic Archives Commission.)

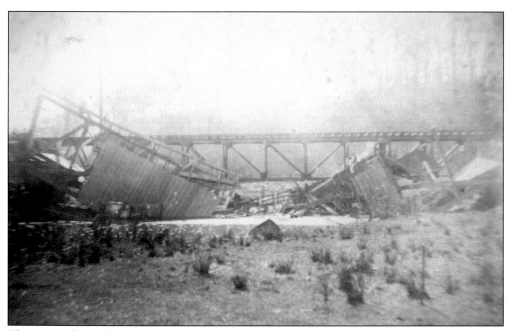

This image shows the collapsed timber bridge that carried traffic over Crum Creek on Baltimore Pike before the Memorial Bridge was constructed. The bridge collapsed on November 12, 1920, under the weight of a truck loaded with potatoes. (Media Historic Archives Commission.)

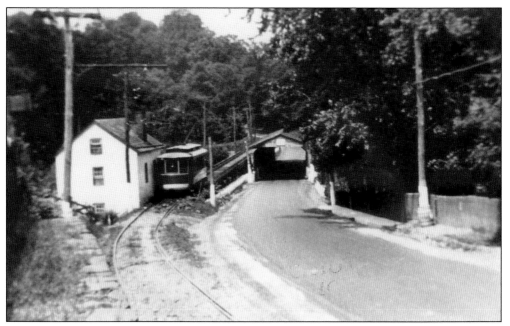

This 1917 photograph shows Baltimore Pike at Crum Creek looking towards Nether Providence. A trolley on the Red Arrow Line is traveling towards Springfield Township next to the Plush Mills Bridge. (Media Historic Archives Commission.)

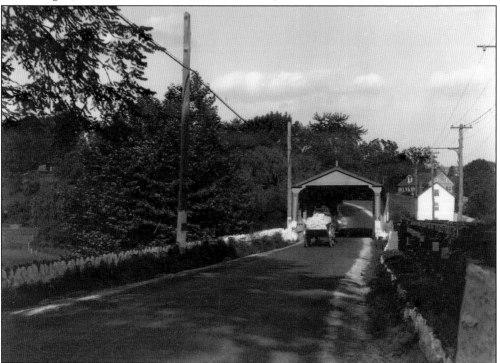

This 1910 picture shows a horse-drawn cart leaving Nether Providence heading towards the Plush Mill Bridge, which led to Springfield Township. The Victoria Plush Mills are to the right of the bridge, and Smedley Park is to the left. (Media Historic Archives Commission.)

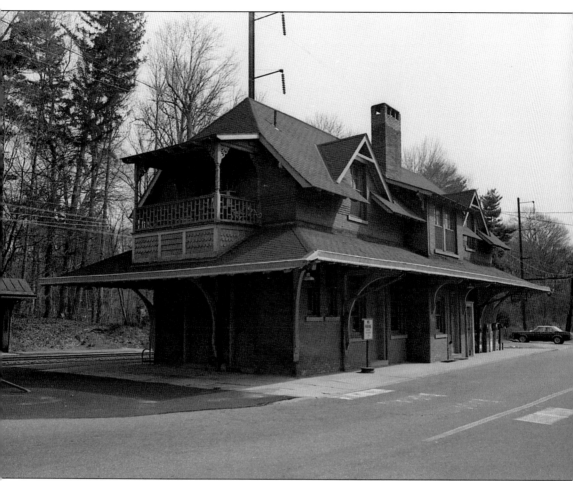

Wallingford Train Station, built in 1890, was designed by Frank Furness, the noted Philadelphia architect, whose brother, Horace Howard Furness, built a country estate in Nether Providence Township called Lindenshade. The train station originally had separate male and female waiting rooms and contained a post office. (Delaware County Planning Commission.)

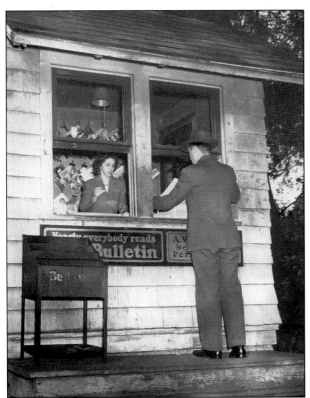

This newsstand, which was very popular with commuters, was owned by the Morton family. It was located next to the post office on Kershaw Road across from Wallingford Train Station. The post office had moved to Kershaw Road in 1920 with Stafford Parker as its postmaster. (Thomas Hibberd.)

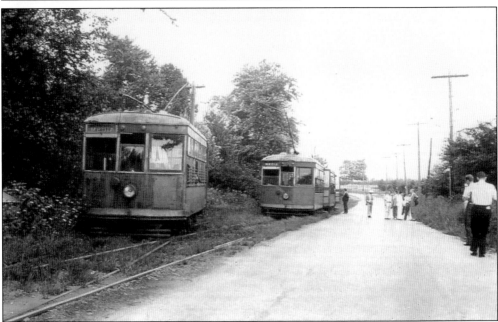

Trolley cars are shown here at Palmer's switch on Rose Valley Road on August 7, 1938. After proceeding up Rose Valley Road to Brookhaven Road, this trolley line made a short path towards the high school, then turned into a private right-of-way that cut over to Woodward Road. (Edward T. Francis.)

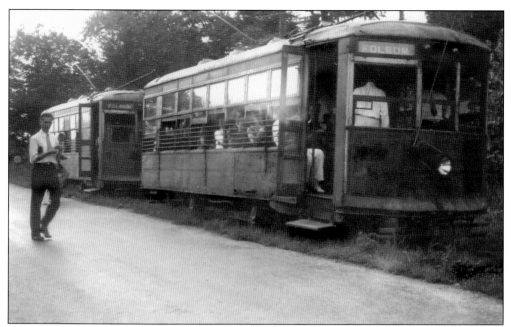

These trolley cars at Palmer's switch at Palmer's Corner were among the last to ride the trolley line, which was abandoned on August 14, 1928. Some of the trolley bridges are still visible on the Rose Valley Swim Club's property, where a private right-of-way was located. (Edward T. Francis.)

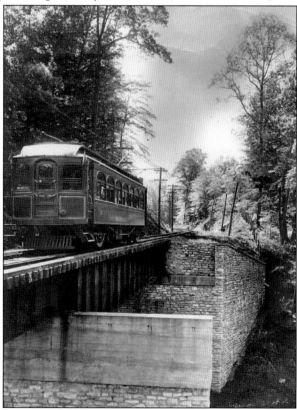

This picture shows a 1913 Red Arrow trolley going to 69th Street in Philadelphia from Media. The photograph was taken in the early 1920s in Smedley Park in Nether Providence Township. (Nether Providence Historical Society.)

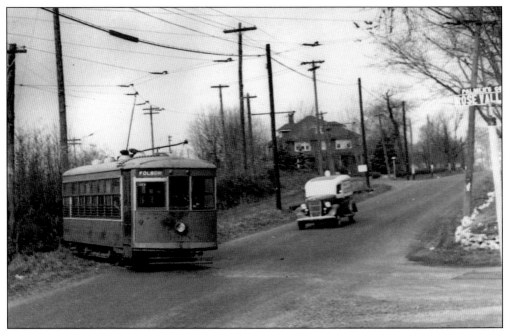

Palmer's Corner is shown in this photograph taken in February 1934. The trolley, already loaded with passengers, is starting on its journey up Rose Valley Road. After a short run down Woodward Road, this trolley line curved past Moylan Train Station and up the hill to Media, Pennsylvania, via Manchester Avenue and Radnor Street. (Stanley F. Bowman Jr.)

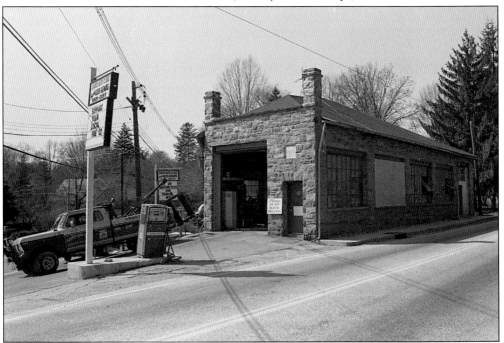

The Sarkis Auto Clinic, an automobile repair shop and gas station, is shown here in 1983. The property, which is still located at the corner of Providence Road and Wallingford Avenue, is now used as an office building. (Delaware County Planning Commission.)

Six
RECREATION AND RELIGION

Chester Park, pictured here in the early 20th century, is located in the City of Chester on the border of Nether Providence. The park, which was a popular place for picnics, fishing, and bathing for Nether Providence residents, was given to the City of Chester by councilman Edward Dickerson. The Chester City Council wanted to call the park Dickerson Park, but Dickerson insisted that the park be named after the city. (Delaware County Institute of Science.)

A horse is shown drinking from a fountain in Chester Park in the early 1900s. Visitors to the park often liked to stroll on the grass by the creek or sit and talk while enjoying the beauty of the landscape. A. J. Duffy operated a refreshment stand for those who did not bring along their own picnic basket. (Delaware County Institute of Science.)

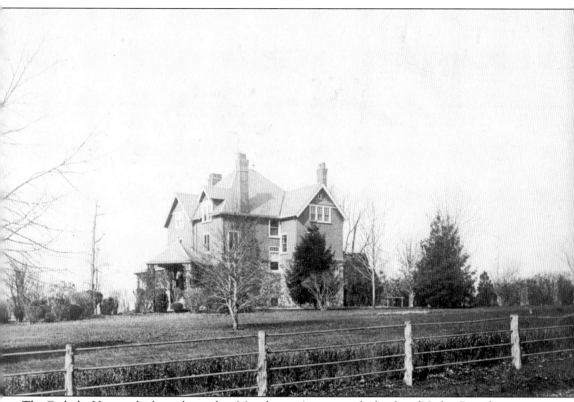

The Catholic Home, which was located on Manchester Avenue on the border of Nether Providence, became a boarding school for girls in 1926. In 1935, it was transformed into a Catholic high school. The school was closed in 1981, and the building was sold to the Pennsylvania Institute of Technology in 1982. (Delaware County Institute of Science.)

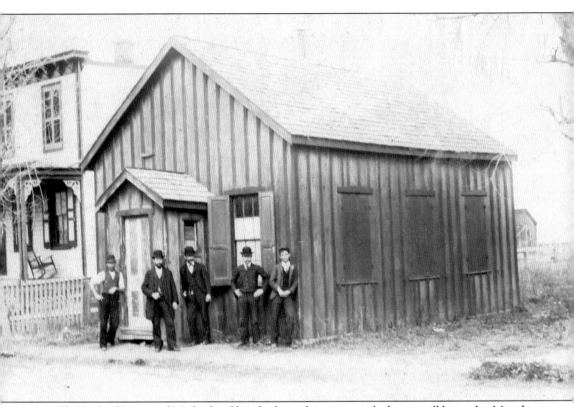

The Packard Memorial Methodist Church, shown here in its early days, is still located at Manchester and Wallingford Avenues in South Media. The church was erected in 1875, but it was completely renovated in 1903. At that time, memorial windows and a new heater were installed, the high altar with a divided chancel was erected, and the roof was replaced. (Delaware County Institute of Science.)

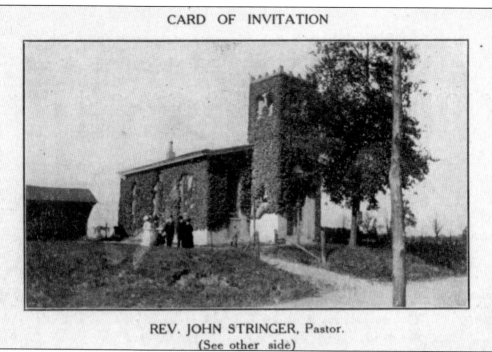

CARD OF INVITATION

REV. JOHN STRINGER, Pastor.
(See other side)

The Union Methodist Episcopal Church, pictured here in 1924, was first erected at the corner of Brookhaven and Rose Valley Roads around 1813. By 1835, the structure was considered unsafe and was demolished. Using the original stones, a new church was built adjacent to the old church. The belfry tower was added in 1869, and in 1891, the stained glass windows were installed. The burial ground adjacent to the church predates the Revolutionary War. The church was originally located in Nether Providence Township but is now considered part of the Borough of Rose Valley. (Media Historic Archives Commission.)

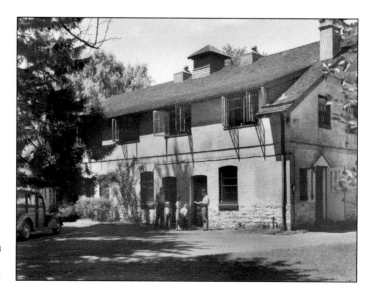

Pendle Hill was founded in 1930 by members of the Religious Society of Friends as a Quaker study center designed to prepare its adult students for service both in the Religious Society of Friends and in the world. An ideal location for the new school was found in Nether Providence Township on Plush Mill Road. Shown here is the barn building, which had a meeting room for worship and lectures. (Pendle Hill.)

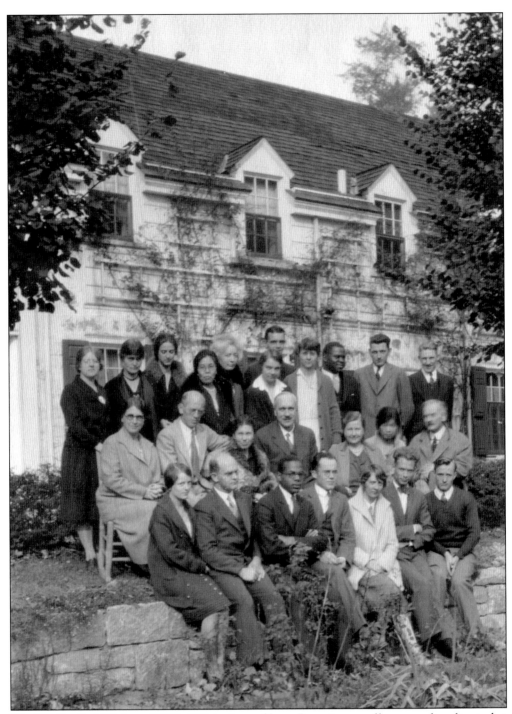

The first Pendle Hill class of 1930–1931 is pictured here. Recruitment efforts were first directed at recent college graduates who had some practical experience and who would come to Pendle Hill to prepare for future service. Students were generally expected to stay for a year's study. Pendle Hill's student body, which was religiously and racially diverse, included students from several countries. (Pendle Hill.)

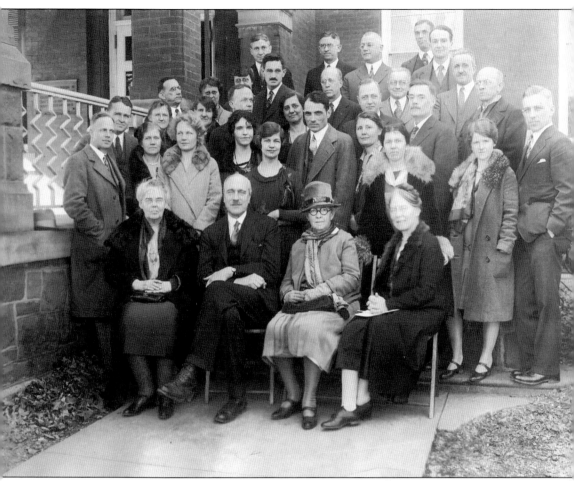

The founders of Pendle Hill included well-known Quaker spiritual leaders, teachers, and business people, some of whom are pictured here. Henry Hodgkin, a well-respected British Quaker, was the first director of Pendle Hill. Howard and Anna Cox Brinton were recruited to serve as directors in 1936. The Brintons led Pendle Hill over the next two decades and were largely responsible for making Pendle Hill a significant Quaker resource for the Religious Society of Friends in the United States and around the world. (Pendle Hill.)

Pictured in this 1934 photograph are members of the Leidy Club on an outing to Leiper's Quarry in Avondale. The Leidy Club, which consisted of people interested in natural history, was named after Joseph Leidy, president of the Academy of Natural Sciences in Philadelphia. He also established the Department of Natural History at Swarthmore College in 1871. (Delaware County Institute of Science.)

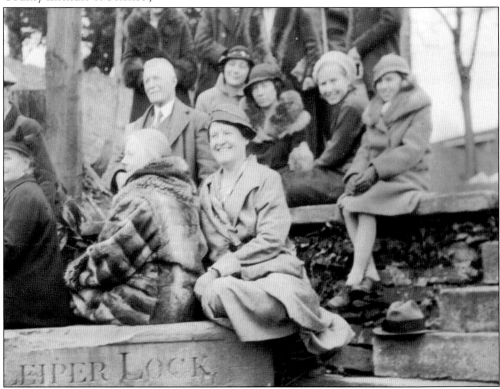

This photograph of the Leidy Club was taken on May 5, 1934, at Leiper's Lock in Avondale. Leiper descendant Mary Leiper (first row, second from left) was a member of the club. Leiper's Canal operated for 23 years along Crum Creek in Nether Providence Township. (Delaware County Institute of Science.)

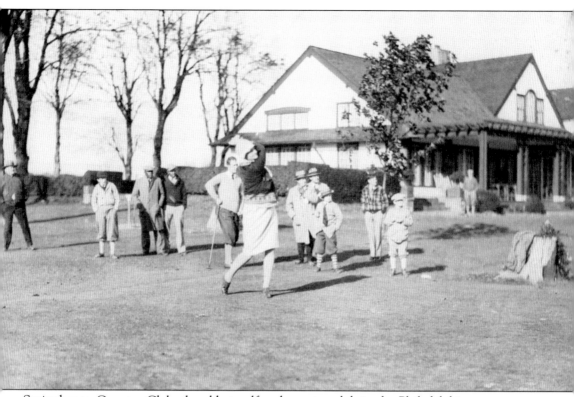

Springhaven Country Club, the oldest golf and country club in the Philadelphia area, was founded in 1896 at Five Points on the site of the old Springhaven farm at Providence Road and Jackson Street in Media, Pennsylvania. The club moved to Wallingford, Pennsylvania, in Nether Providence Township in 1904. The clubhouse, pictured here in the 1920s, featured a large assembly hall, dining room, taproom, and accommodations for overnight guests. (Nether Providence Historical Society.)

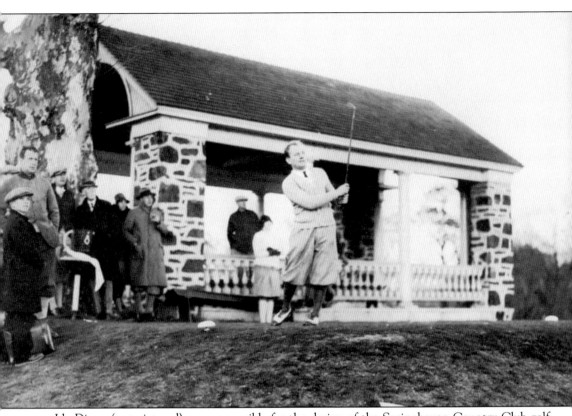

Ida Dixon (not pictured) was responsible for the design of the Springhaven Country Club golf course, making her the first female golf architect in America. Dixon would serve as president of the Women's Golf Association of Philadelphia from 1911 through 1916. The Springhaven Country Club was officially dedicated at its new Wallingford location on July 9, 1904. (Nether Providence Historical Society.)

Pictured here in the late 1940s is the Schaefer home on Providence and Chester Roads in Nether Providence Township. The Schaefer home and surrounding property were eventually sold to Congregation Ohev Sholom. The congregation's new synagogue, designed by architect Percival Goodman, was built on the site in the early 1960s. (Mary and Karl Schaefer.)

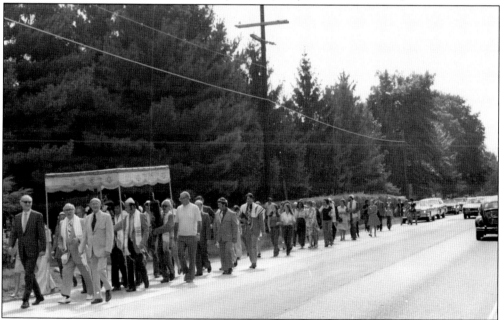

In 1973, members of Congregation Mispallilim, a synagogue that had been located in the City of Chester, carried the congregation's torahs to Congregation Ohev Sholom in Nether Providence Township. The two congregations had split in 1924 but were reunited after almost 50 years when the congregations merged in 1973. Leading the procession along Providence Road are, from left to right, Rabbi Louis Kaplan, Harry Kaplan, and Judge Louis A. Bloom. (Congregation Ohev Sholom.)

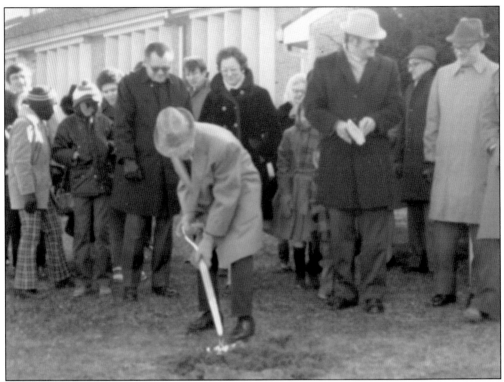

In the mid-1970s, Holy Trinity Lutheran Church, located at 927 South Providence Road, decided to build a social hall and educational classrooms adjacent to its new sanctuary. Over $102,000 was raised for this building, which was completed in 1975. Shown here at the groundbreaking for the new building is church member August E. Fischer. (Judy Hash.)

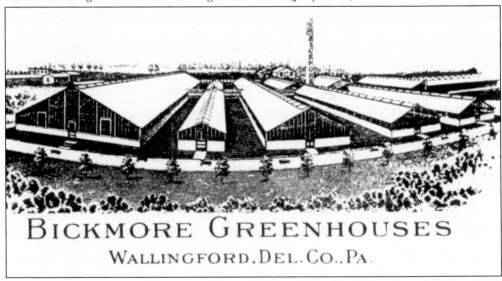

Milton H. Bickley purchased a 102-acre farm off of Rose Valley Road from James Miller in 1915. Bickley raised a variety of flowers in 19 greenhouses on the property, which he later named Bickmore Farms. Bickmore Farms existed for over 40 years, until a major subdivision called Bickmore Estates was developed on the property in the mid-1960s. (J. Mervyn Harris.)

Seven
A Summer Retreat for the Wealthy

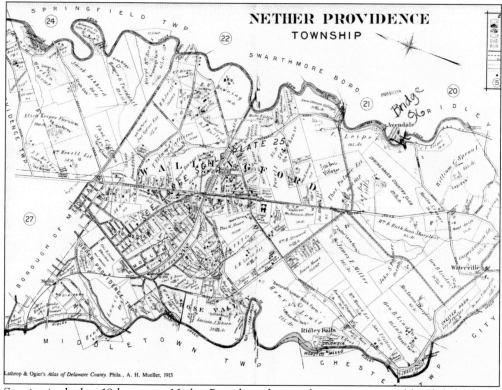

Starting in the late 19th century, Nether Providence became home to many wealthy Philadelphians who were looking for a tranquil and beautiful place to build their summer homes. This 1913 map of Nether Providence Township shows where many of these new Nether Providence residents built their homes. For about 40 years, the township rivaled the "Main Line" of Philadelphia in terms of both prestige and spaciousness. (Nether Providence Historical Society.)

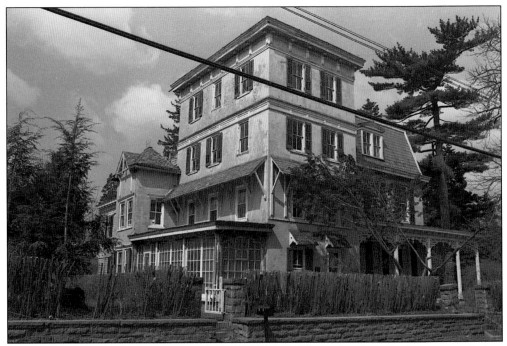

The main section of this home located at 41 South Providence Road was built sometime before 1777. In 1875, the house was expanded by adding a three-story second empire wing. In 1895, a two-story kitchen and service wing was added. The home was owned in the late 19th century by Alfred Gillette, the owner of the *Philadelphia Times*. Gillette was married to a member of the well-known Gratz family of Philadelphia. (Delaware County Planning Commission.)

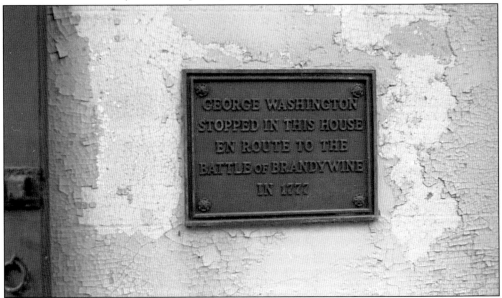

George Washington visited this home located at 41 South Providence Road on his way to the Battle of Brandywine. In 1926, a bronze marker was placed on the east wall of the home by the Delaware County Historical Society memorializing this interesting bit of local history. (Delaware County Planning Commission.)

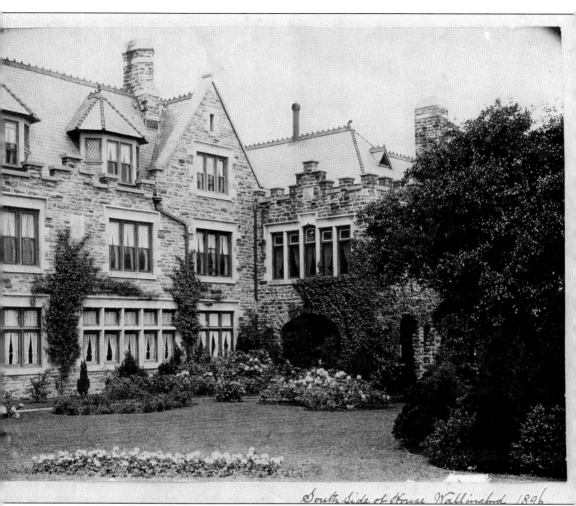

South Side of House Wallingford 1896

This 1889 mansion, which was built as a summer home by Pennsylvania Railroad executive Henry P. Dixon and his wife, Ida E. Dixon, was originally part of a larger property owned by Mordecai Lewis, a wealthy mill owner. In 1913, the property was sold to Samuel Crothers. In 1968, the Wallingford Community Arts Center purchased the property form the Crothers family and began the work of preserving the architectural and historical details while converting the facility for use as a working center for the arts. (Wallingford Community Arts Center.)

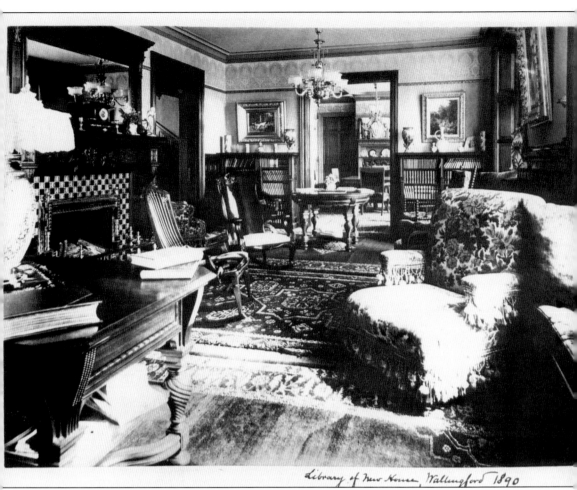

Library of new house, Wallingford 1890

This 1890 picture shows the front room and dining room of the home owned by Henry P. Dixon and Ida E. Dixon. Wood paneling was used throughout the house, and all of the windows had interior shutters that were integrated into the wood window surrounds. Currently the Wallingford Community Arts Center uses the front room as gallery space and the dining room as its main office. (Wallingford Community Arts Center.)

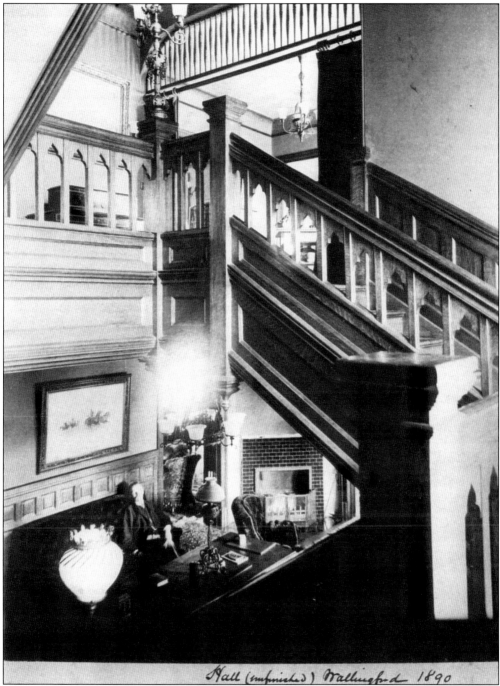

The Dixon home, which was commonly referred to as "the Gables," was elegantly constructed with a wide staircase and fireplaces in every room. Careful planning is evident in the design of each fireplace in the building. Several have intricately carved mantels and surrounds and most incorporate Mercer tile. This 1890 photograph shows the unfinished front hall from the landing between the first and second floors. There are gas lamps on the staircase and the walls. The fireplace surround is incomplete. (Wallingford Community Arts Center.)

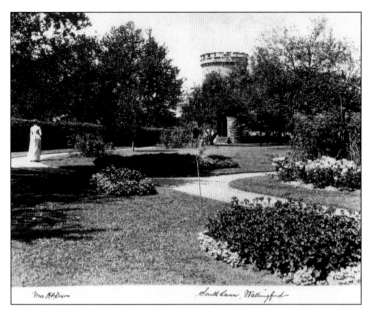

This photograph, also taken in 1890, shows Ida E. Dixon strolling on the south lawn of her Nether Providence estate. The property was beautifully landscaped. Many of the original plantings remain today. The large copper beech tree at the rear of the property and the unique cucumber magnolia along the driveway are both over 100 years old. (Wallingford Community Arts Center.)

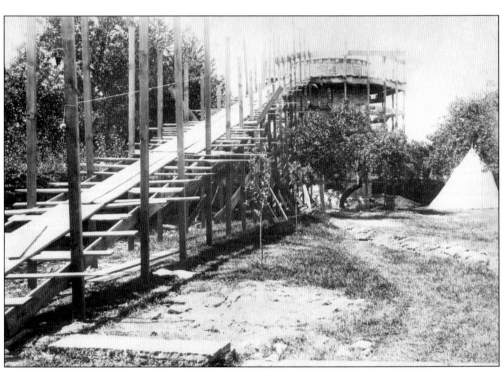

A unique feature of the Dixon home was the tower at the rear of the property. The stone tower was built around a wooden water tower that had previously been located on the property. The tower is one of only two remaining residential water towers in Delaware County, Pennsylvania. (Wallingford Community Arts Center.)

This summer home, which was commonly referred to as Netherworth, was built by James Watts Mercur and his wife around 1880. James Mercur was the son of Ulysses Mercur, who was chief justice of the Pennsylvania Supreme Court from 1883 until his death in 1887. (Nether Providence Historical Society.)

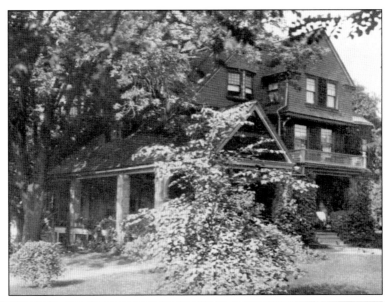

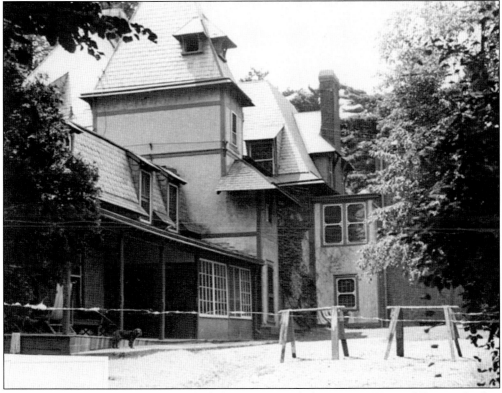

In the late 19th century, renowned Shakespearean scholar Horace Howard Furness built a magnificent summer home in Nether Providence Township called "Lindenshade." The house, which was located at the end of what is now Furness Lane, was designed by his brother, noted Philadelphia architect Frank Furness. The property has been demolished, with the exception of a brick building that once functioned as the estate's library. That building is now a private residence. (Library of Congress.)

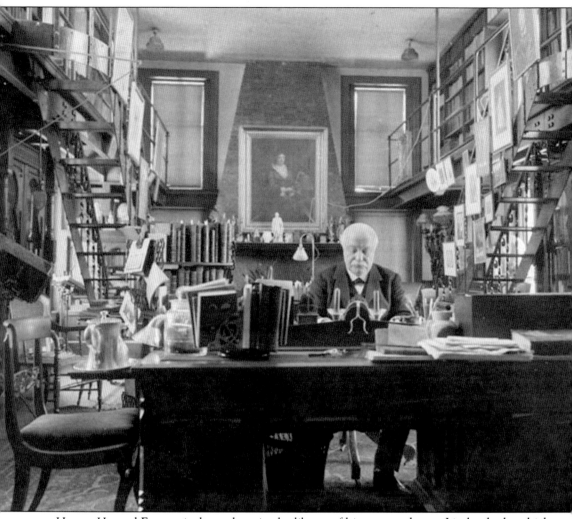

Horace Howard Furness is shown here in the library of his summer home, Lindenshade, which was located in Nether Providence Township. The library housed several priceless Shakespearean treasures and a range of original sources. There were many famous visitors to Lindenshade, including Ralph Waldo Emerson and Walt Whitman. (Library of Congress.)

T. Ellwood Allison built a 40-room Gothic mansion in 1905 off of Turner Road called "Cony Meade." After it was destroyed by a fire in 1981, township officials James Zito (on the left) and Gary Cummings inspected the property. By the time the property was demolished, it was infamously known as "the Castle." (Nether Providence Township.)

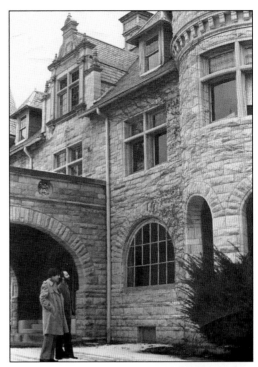

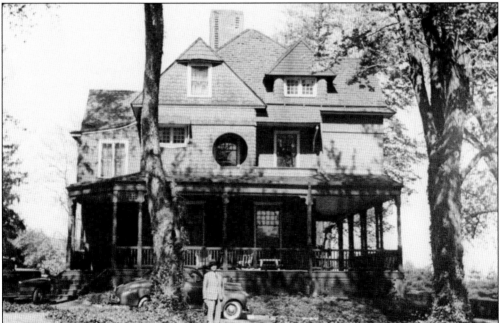

The home of Dr. Joseph Kassab, shown here in 1941, was built in 1887 as one of the first permanent residences during the period of summer home construction. The house is still located at the corner of Brookhaven and Providence Roads. The buying of properties in this area by wealthy Philadelphians caused a rapid increase in the land value in this part of Nether Providence Township. The cost of land increased from $200 per acre to over $1,500 per acre during this time. (Nether Providence Historical Society.)

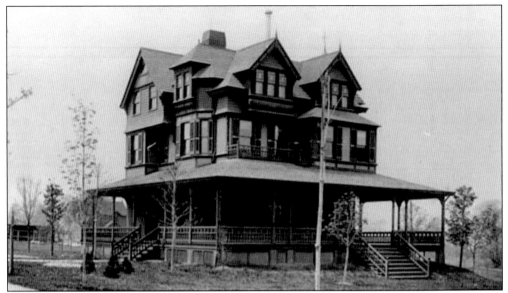

This home near Hinkson's Corners, built in 1883, was the summer home of Edward Gratz and his wife, Caroline Vandeveer. Edward Gratz also established summer homes for his three daughters around Hinkson's Corners. One of his daughters married Alexander J. McClure, a friend and confidant of Pres. Abraham Lincoln. Another home was built for the daughter who married Felix De Cranos, the French general counsel. A third home was built for a daughter who married Alfred S. Gillette, owner of the *Philadelphia Times*. (Media Historic Archive Commission.)

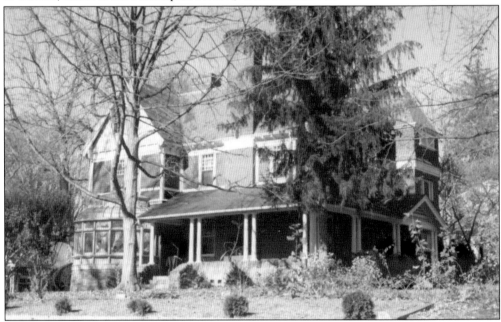

This Queen Anne–style residence located at 123 North Providence Road was built by Charles Essig in 1882. Named "Westlawn" by its owner, the home was listed on the National Register of Historic Places in 1988. Although houses of this style were being built elsewhere in the Philadelphia area, there are no other known surviving examples in Nether Providence Township. (Media Historic Archives Commission.)

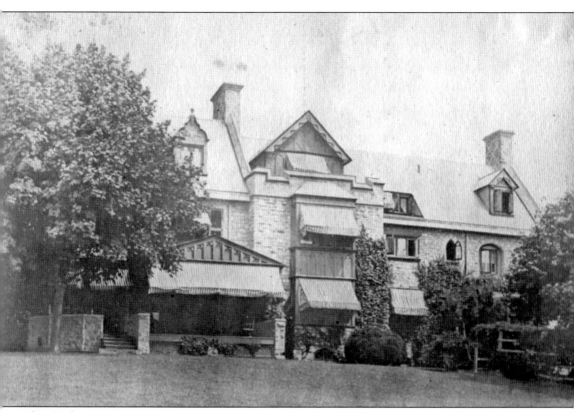

This Gothic mansion on Rose Valley Road was built for Charles and Harriet Bean in 1893. The home would later be owned by John G. Pew, then by Mr. and Mrs. Walter M. Strine Jr. The property, which was called "Gothwold," had one of the first nine-hole golf courses in the country. Although the property was located in Nether Providence Township when it was built, it is now located in the Borough of Rose Valley. (Media Historic Archives Commission.)

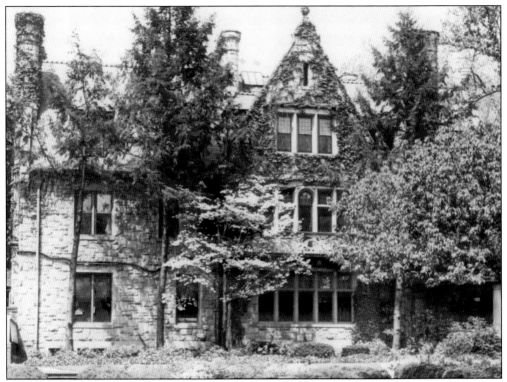

In 1892, James Little and his wife built this mansion called "Oak Knoll" on Avondale Road in Nether Providence Township. Mrs. Little's father was William R. Bucknell, a Philadelphia real estate tycoon and founder of Bucknell University. Her mother, Emma Eliza Ward Bucknell, survived the Titanic disaster. Oak Knoll was later the home of Mr. and Mrs. J. H. Ward Hinkson, who were internationally known for growing rare orchids on the property. The house was torn down in 1967 to make way for the Blue Route. (Nether Providence Historical Society.)

Former governor of Pennsylvania, William Cameron Sproul, was a City of Chester resident and local businessman. After marrying Emeline Roach, daughter of shipbuilder John B. Roach, he bought this house, which had been built by Thomas Leiper for his son, James, in 1818. Governor Sproul named the property "Lapedea Manor" and expanded the estate by buying up the surrounding land. Eventually the estate would contain 157 acres stretching from Bullens Lane to Crum Creek, and from the Ridley Township border to Rose Valley Road. (Nether Providence Historical Society.)

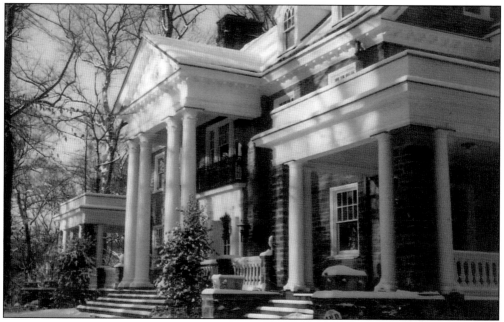

Howard H. Houston, the mayor of the City of Chester from 1902 until 1906, built this home called "Houstonia" overlooking Ridley Creek at the southern end of Nether Providence Township. Mayor Houston, as the one-time director of the Chester and Media Electric Railway, was responsible for bringing that trolley line into Nether Providence Township. The home is now owned by Marc and Jamie Lapadula, who are in the process of restoring it to its original condition. (Marc and Jamie Lapadula.)

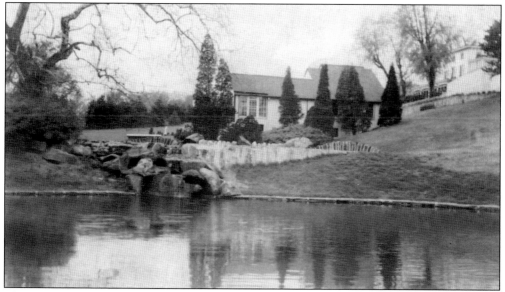

The Sykes Estate, pictured here in 1948, was once owned by Anne Kershaw, who married into the Sykes family. Her son, John P. Sykes, later inherited the property and expanded it. When the estate's dogwood trees were in bloom, sightseers clogged Avondale Road from Brookhaven Road to Copples Lane, and Brookhaven Road from Providence Road to Avondale Road, much to the annoyance of local residents. (Nether Providence Township.)

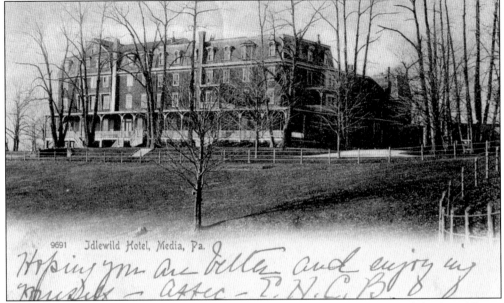

The Idlewild Hotel, pictured here on a 1905 postcard, was a summer resort built by David Reese Hawkins in 1871 in nearby Upper Providence Township. It had 150 rooms, a bowling alley, a ballroom, water-powered elevators, and a golf course. The hotel was closed in 1926 and torn down in 1933. Visitors to the Idlewild Hotel would usually arrive by train at Nether Providence Township's Moylan Train Station, where hotel carriages would meet arriving guests and transport them to the hotel. (Nether Providence Historical Society.)

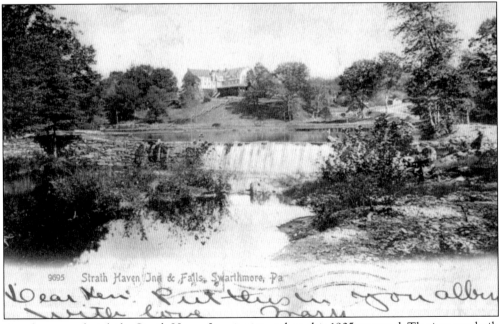

Another resort hotel, the Strath Haven Inn, is pictured on this 1905 postcard. The inn was built in 1892 on a hill above Yale Avenue and Crum Creek Falls in Swarthmore, Pennsylvania, right outside of Nether Providence Township. The inn closed in 1960 and is now the site of the Strath Haven Condominiums in Swarthmore. (Delaware County Institute of Science.)

Eight
THE ARTS AND CRAFTS COMMUNITY

In 1901, William Lightfoot Price, a successful Philadelphia architect, came to the Rose Valley area with his young family to start an arts and crafts community. He bought 80 acres (in what was then Nether Providence Township) in the name of the Rose Valley Association from the bankrupt estate of Antrim Osborne. The Borough of Rose Valley split from Nether Providence Township and became its own municipality in 1923. (E. Morris Potter.)

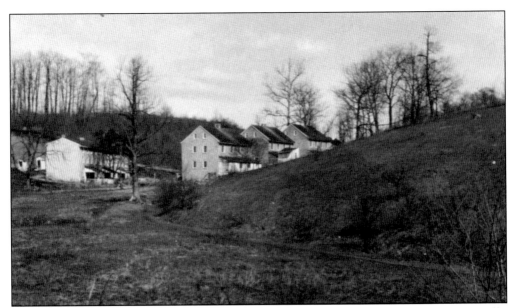

To provide housing for his many workers, Antrim Osborne, the owner of the Rose Valley mills, built 12 six-room houses: six in a continuous row on the east side of Rose Valley Road and three double houses across the street. The houses were completed in 1870. Later, after the mills were bought by the Rose Valley Association, the mill houses were used to house visiting artists and craftsmen. (E. Morris Potter.)

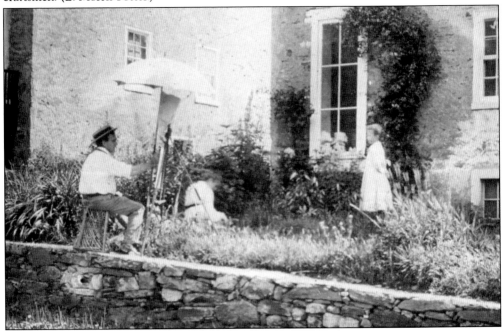

In this early 20th century photograph, artist Frank Day paints a young girl in front of the mill houses on Providence Road. Frank Day was a portrait painter and illustrator and maintained a studio in Guild Hall in Rose Valley. He, Carl DeMoll, Nathan Kite, and Will Price drew up the charter for the Rose Valley Folk. He is also reputed to have designed the Rose Valley Seal. (E. Morris Potter.)

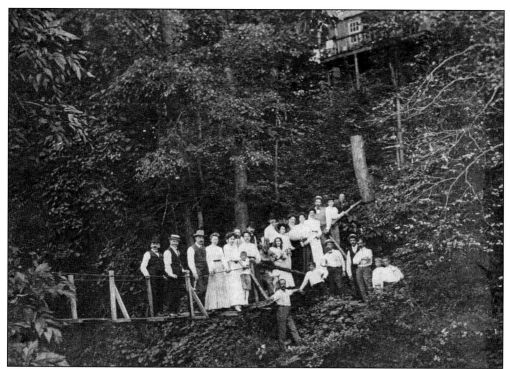

Rose Valley residents are pictured here in the early 1900s on a swinging bridge leading to Longpoint cabin. At the time, the cabin was used by a social outing group known as the "S. A. K." (Seekers After Knowledge). The S. A. K. often played cricket behind the Old Mill or on the lawn of William Lightfoot Price's house on Rose Valley Road. (E. Morris Potter.)

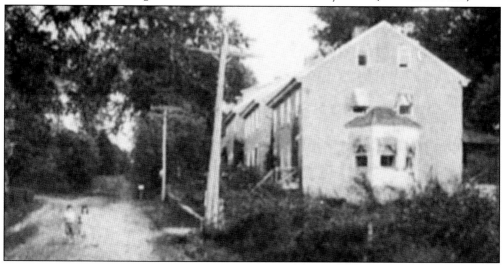

In this early 20th century postcard, a young boy and girl are walking down Providence Road in front of the mill houses. When the Rose Valley Association first bought the mill houses from the Osborne estate, they were old and uninhabitable. William Lightfoot Price later rehabilitated the houses, converting six of the twelve units into a structure known as the "Guest House." The houses' red tile roofs and buff plaster became familiar features of the many houses that Price renovated or designed in Rose Valley. (E. Morris Potter.)

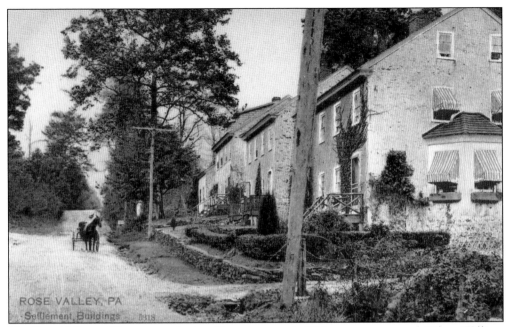

The Rose Valley mill houses are depicted here in an early 20th century postcard. When William Lightfoot Price rehabilitated the houses, he provided contrasting colors and artistic touches with carvings, buttresses, and insets of colored Mercer tile in order to break up the simplicity of the plastered exteriors. The houses' red tile roofs and buff plaster became familiar features of the many houses that Price renovated or designed in Rose Valley. (E. Morris Potter.)

The Guest House on Providence Road in Rose Valley was used as an inn at one time by the Rose Valley Association under the management of the Kite family. Visitors to the inn included Horace and Ann Traubel and their daughter, Gertrude. Horace Traubel, the editor of a Camden newspaper, established the Rose Valley Print Shop in Philadelphia, which issued a small monthly magazine called *The Artsman*. (Timothy Plummer.)

William Lightfoot Price's sister, Anna, and her husband, Nathan Kite, served as innkeepers of the Guest House Inn while the visiting artists worked. The Kites, who are pictured here with their daughter, Dorothy, made an attractive, hand-carved sign, printed in illuminated English lettering, which became the familiar sign of the Guest House. Unfortunately the sign, which is visible in the upper left corner of this early 20th century photograph, has been lost. (E. Morris Potter.)

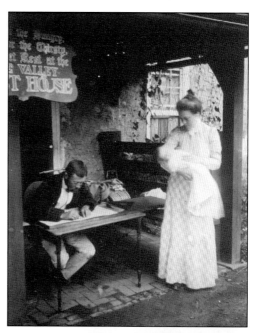

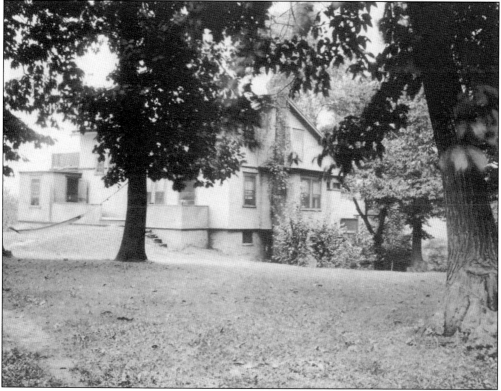

Pictured here is "Good Intent," the house that Nathan and Anna Kite built on Vernon Lane in Rose Valley. Nathan Kite is best remembered for having written a first-hand account of the beginning of the Rose Valley community. When Rose Valley became a borough in 1923, Nathan Kite was its first burgess. (E. Morris Potter.)

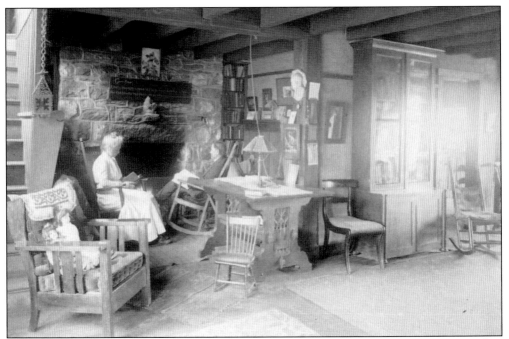

Nathan and Anna Kite are shown here relaxing inside their home on Vernon Lane in Rose Valley. Anna Kite trained as a kindergarten teacher in Baltimore. She then taught in West Philadelphia before moving to Rose Valley. She ran a kindergarten for 15 years at their home on Vernon Lane and organized many community events, including Robin Hood plays on the lawn and Christmas caroling around the valley. (E. Morris Potter.)

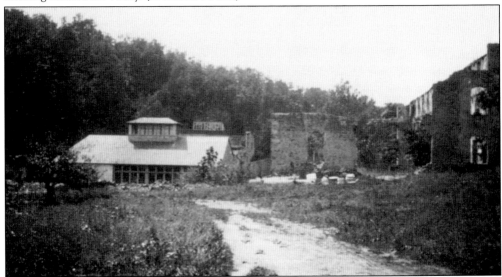

The Rose Valley Furniture Shop, which is shown here in an early 20th century photograph, opened in 1902 at the Old Mill on Ridley Creek. Foremost among the craftsmen at the shop was John Maene, born and trained in Belgium, who was an instructor in wood carving and modeling at Drexel Institute (now Drexel University). He and his family stayed at the Bishop White house on Old Mill Lane for $6 a month. Other craftsmen were housed at the mill houses on Rose Valley Road for $11 a month. (E. Morris Potter.)

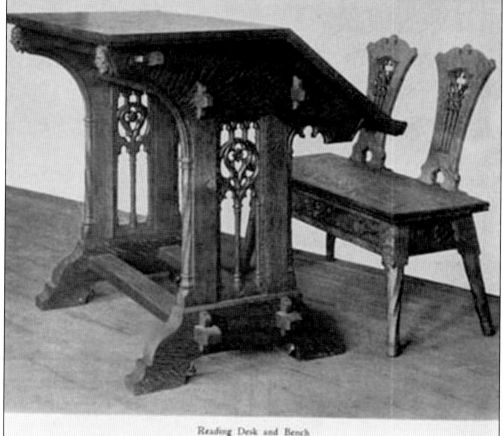

Shown here is a 1902 advertisement for the Rose Valley Shops in *House and Garden* magazine. The Rose Valley Shop seal was a buckled belt encircling a wild rose with the letter "V" on the face of its petals. The seal was stamped on all Rose Valley Shop products as a mark of identity and as a guarantee of honest construction. (E. Morris Potter.)

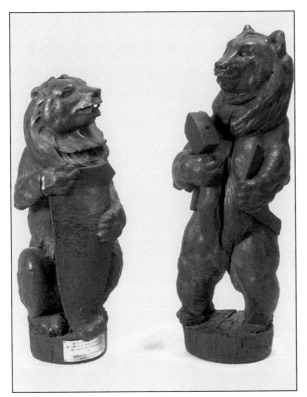

In 1902, David Lightfoot, a cousin of the Prices, carved two bears from whole chestnut logs to mark the entrance to the furniture shop on Old Mill Lane. The bears disappeared from the community at least twice, once held captive by a Swarthmore College fraternity. (E. Morris Potter.)

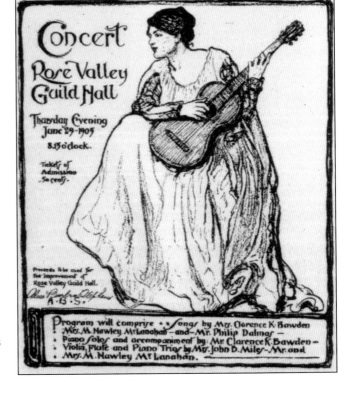

Guild Hall, or Artsman's Hall as it was sometimes called, was used by local Rose Valley residents to perform concerts, dances, and plays. Shown here is an advertisement for a concert on June 29, 1905, by local residents. Tickets to the concert cost 50¢, and proceeds went to help improve Guild Hall. (E. Morris Potter.)

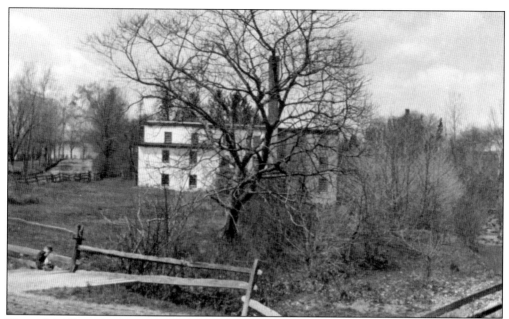

Hutton's Mill was built in 1842 by Thomas Hutton to grind feed for farmers' livestock and meal and flour for human use. Around 1900, the old Hutton Mill was remodeled by local Rose Valley craftsmen into a local community center called "Guild Hall." Shown here in an early 20th century photograph, the hall was first used on New Year's Day 1904 but was not formally opened until the last night of that year. (E. Morris Potter.)

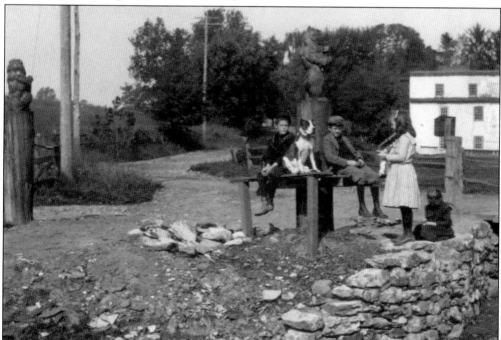

In this early 20th century photograph, local Rose Valley children are seen playing at the entrance to Old Mill Lane in front of Guild Hall. The Rose Valley bears, which were made by David Lightfoot in 1902, mark the entrance to Old Mill Lane. Guild Hall is across the street to the left. (E. Morris Potter.)

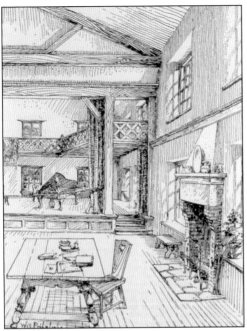

Shown here is a sketch of the interior of Guild Hall made by William Lightfoot Price in 1903. In 1922, Jasper Deeter, a visionary director, came to Rose Valley and fell in love with the intimacy of Guild Hall. In 1923, he helped turn Guild Hall into the Hedgerow Theatre. Deeter's creative energy drew many talented actors, playwrights, and directors to Hedgerow, earning Hedgerow an international reputation and the distinction of being the first resident repertory theatre in the country. Hedgerow was a premier meeting ground for major actors of stage and screen in the 1920s and 1930s. (E. Morris Potter.)

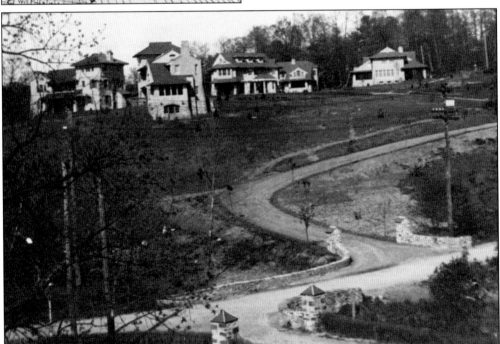

Around 1910, Charles T. Schoen and his son-in-law, Hawley M. McLanahan, formed the Rose Valley Improvement Company. The two men commissioned William Lightfoot Price to build five speculative houses on one of the tracts owned by McLanahan to try to raise money and increase the population of the community. The houses were situated on and around Porter Lane, which originally ran from the west side of Possum Hollow Road through to Rose Valley Road, emerging between the Hedgerow Theatre and the Guest House. The first of the houses was not sold until 1915. (E. Morris Potter.)

Nine
THE DEVELOPERS ARRIVE

In 1885, a group of businessmen created Nether Providence Township's first housing development, which was called South Media. They purchased 32 acres along Manchester Avenue and laid out a community in blocks 30 feet wide and 140 feet deep. The lots sold for an average of $75 payable at $1 a week. Pictured here are some early South Media residents. (Media Historic Archives Commission.)

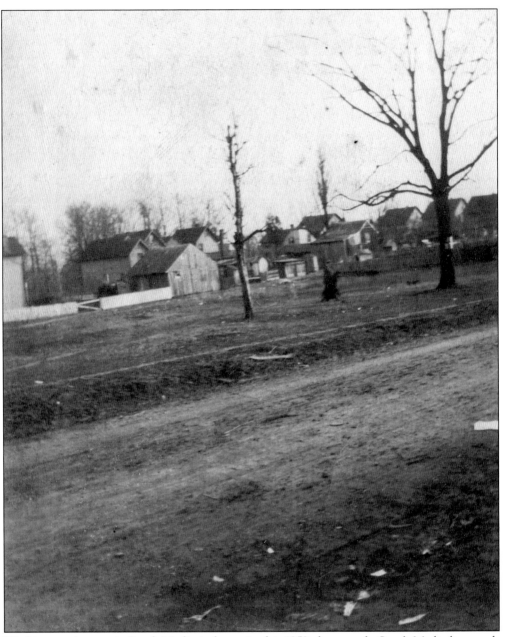

Washington Avenue in South Media is shown in this 1959 photograph. South Media lies north of Wallingford and Rose Valley and west of North Providence Road. East Baltimore Pike is usually considered the area's northern border. South Media has the oldest fire company in Nether Providence Township. (Media Historic Archives Commission.)

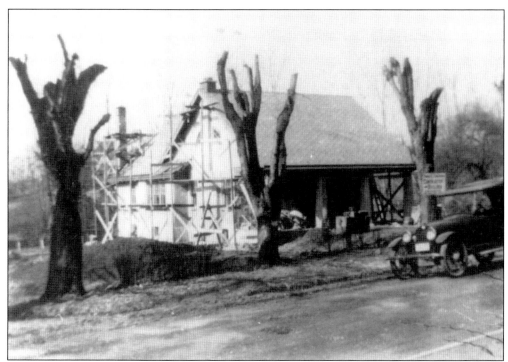

A new house is being built on Wallingford Avenue in this 1920s photograph. In 1930, Nether Providence became the first township in Pennsylvania to adopt a zoning ordinance. The ordinance, which was amended in 1940, divided the township into 12 zones: six residential, four commercial, and two industrial. (Charles Morris.)

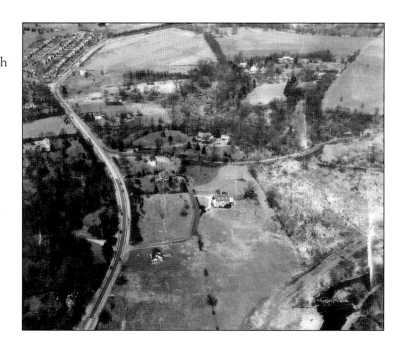

This aerial photograph shows the beginning of development in Nether Providence Township. In the upper left corner of the picture is the Medbury development off of Routes 320 and 252. The buildings toward the top right of the photograph are part of Governor Sproul's old property, which would later become the Sproul Estates. (Nether Providence Historical Society.)

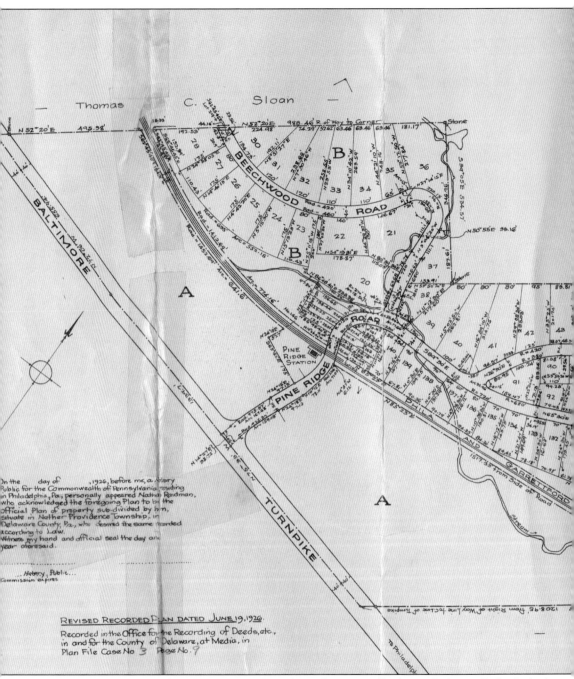

Shown here are plans for a development along the Red Arrow trolley line called "Pine Ridge," which was built on Horace G. Twaddell's 89-acre estate. The plan for the development was prepared in 1926 by Nathan Raidman of Philadelphia. The development was adjacent to the farms of Jacob

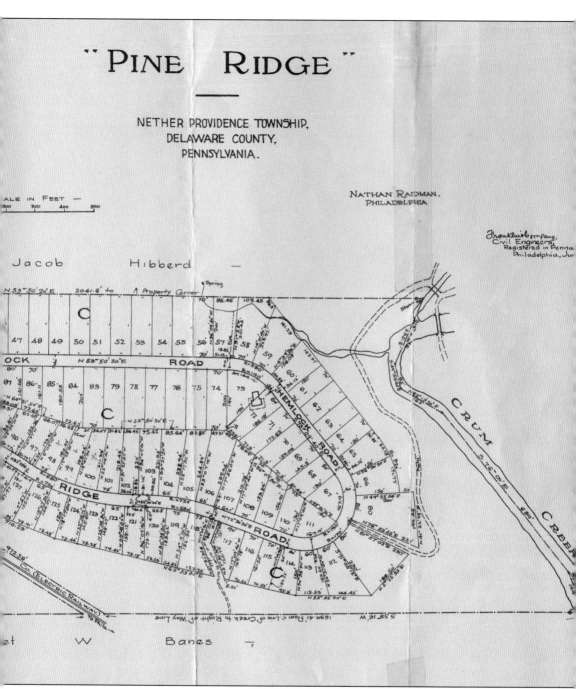

Hibbert and Thomas C. Sloan and was located just off of Baltimore Pike (then called Baltimore Turnpike). (Nether Providence Township.)

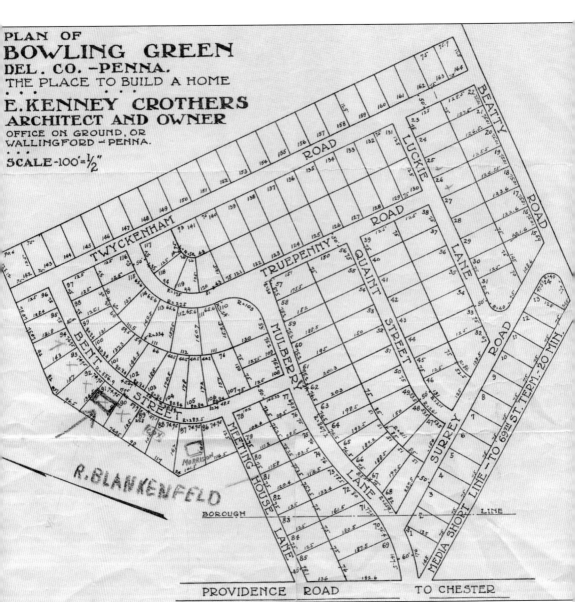

Development in Nether Providence Township generally followed the township's transportation lines. Shown here is the plan for "Bowling Green," a development off of Providence Road and Beatty Road, along the Red Arrow trolley line. The development was built on 58 acres owned by William Howell. (Nether Providence Township.)

"Lapidea Hills," a development that was adjacent to the Springhaven Country Club and named for Gov. William Cameron Sproul's estate, opened in 1925. Pictured above is a photograph used in a 1940 advertisement for the development in the *Delaware County Advocate* magazine. (Nether Providence Historical Society.)

Shown at right is another magazine advertisement for the Lapidea Hills development. Homes in the development were priced from $14,500 to $15,500. Each home had a two-car garage and log-burning fireplace, and provided the benefits of "healthful outdoor play." (Nether Providence Historical Society.)

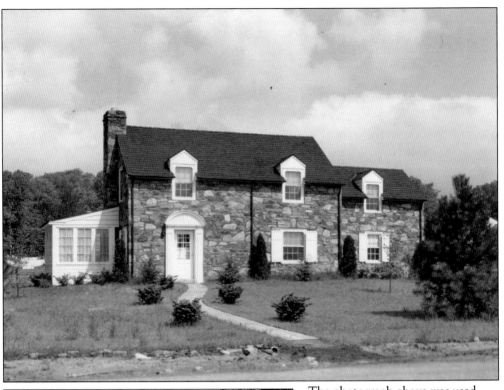

The photograph above was used in a 1940s advertisement in the *Delaware County Advocate*. The advertisement was for a new development in Nether Providence Township called "Providence Village," which was built in the late 1930s between Golf View Road and Providence Road on what was then the Palmer-Ryan farm. (Nether Providence Historical Society.)

This 1940s magazine advertisement, also for Providence Village, boasted that the development was located across from a golf course and near canoeing and skating on nearby Crum Creek. These houses started at $6,775 and, according to the advertisement, went as high as $9,430. (Nether Providence Historical Society.)

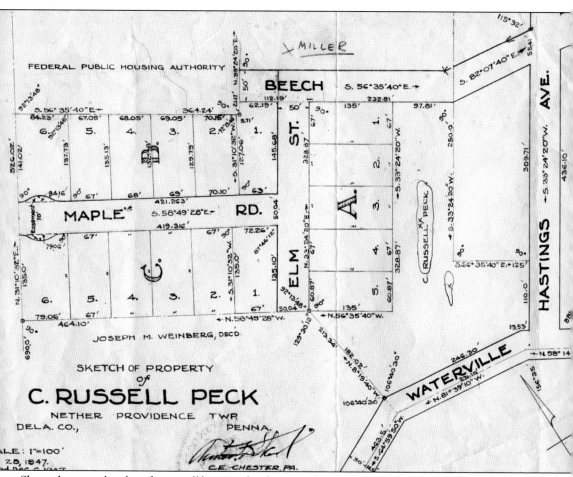

Shown here are the plans for a small housing development that was to be built primarily for residents who worked in factories along the river. The development, built by the Federal Public Housing Authority in the 1940s, was located just off of Waterville Road. (Nether Providence Township.)

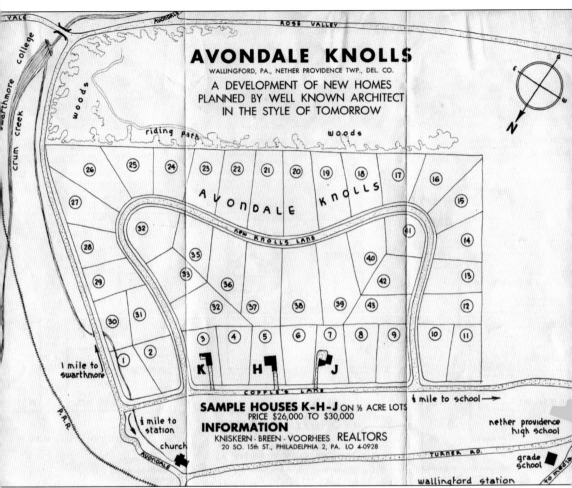

"Avondale Knolls" was a development with 43 lots that was built in the late 1940s off Copples Lane and Avondale Road. The development was in walking distance to Nether Providence High School and not far from the Wallingford train station. (Nether Providence Township.)

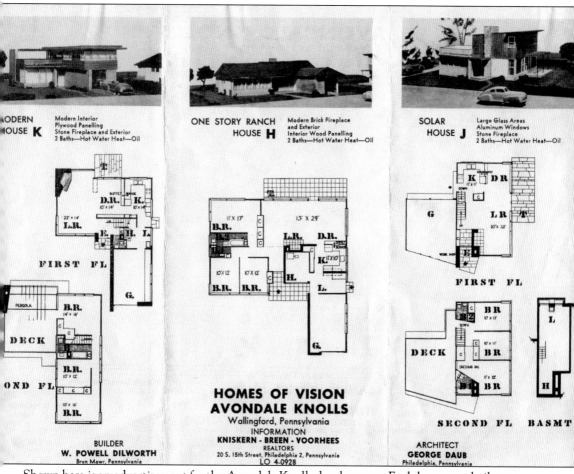

Shown here is an advertisement for the Avondale Knolls development. Each house was built on a half-acre of land. There were three different styles of homes, all with three bedrooms, two baths, and a fireplace. The homes were built "in the style of tomorrow" and were priced from $26,000 to $30,000. (Nether Providence Township.)

DISCOVER THOUSANDS OF LOCAL HISTORY BOOKS FEATURING MILLIONS OF VINTAGE IMAGES

Arcadia Publishing, the leading local history publisher in the United States, is committed to making history accessible and meaningful through publishing books that celebrate and preserve the heritage of America's people and places.

Find more books like this at
www.arcadiapublishing.com

Search for your hometown history, your old stomping grounds, and even your favorite sports team.

Consistent with our mission to preserve history on a local level, this book was printed in South Carolina on American-made paper and manufactured entirely in the United States. Products carrying the accredited Forest Stewardship Council (FSC) label are printed on 100 percent FSC-certified paper.